# SECRET
# BOURNEMOUTH

Andrew Jackson

AMBERLEY

First published 2023

Amberley Publishing
The Hill, Stroud
Gloucestershire, GL5 4EP

www.amberley-books.com

Copyright © Andrew Jackson, 2023

The right of Andrew Jackson to be identified as the
Author of this work has been asserted in accordance
with the Copyrights, Designs and Patents Act 1988.

ISBN  978 1 3981 0754 0 (print)
ISBN  978 1 3981 0755 7 (ebook)

British Library Cataloguing in Publication Data.
A catalogue record for this book is available from the
British Library.

Origination by Amberley Publishing.
Printed in Great Britain.

# Contents

# Introduction

Prior to the early nineteenth century, the area of land now known as Bournemouth was owned by Sir George Ivison Tapps. It consisted of desolate sand dunes and heathland intersected by steep-sided ravines, known as 'chines'.

In 1810, a former army officer of the Dorset Yeomanry, Lewis Dymoke Grosvenor Tregonwell, a Dorset man from nearby Anderson, decided to show his wife, Henrietta, the area he had patrolled whilst looking out for smugglers and a potential French invasion during the time of the Napoleonic Wars.

The Tregonwells fell in love with the area, and bought 81/2 acres of land from George Tapps, on which they had a house built, before taking up residence in 1812. The remnants of these buildings still exist today as part of the Royal Exeter Hotel.

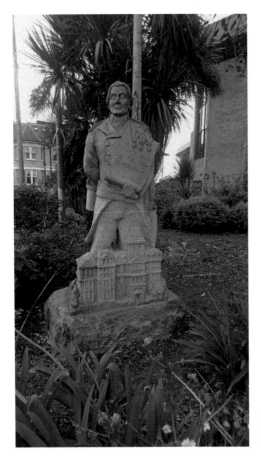

A statue of Lewis Dymoke Grosvenor Tregonwell situated outside the Bournemouth International Centre (BIC).

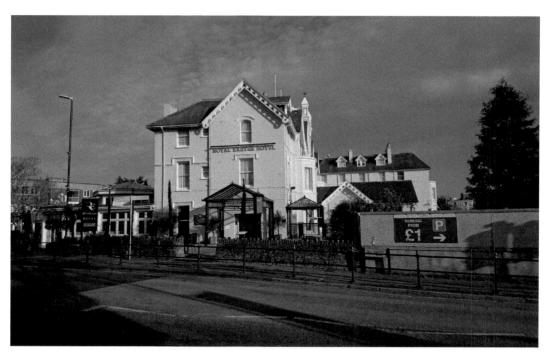

The Royal Exeter Hotel is at the site where the Tregonwells first made their home in Bournemouth and some of the remnants of the original buildings still exist.

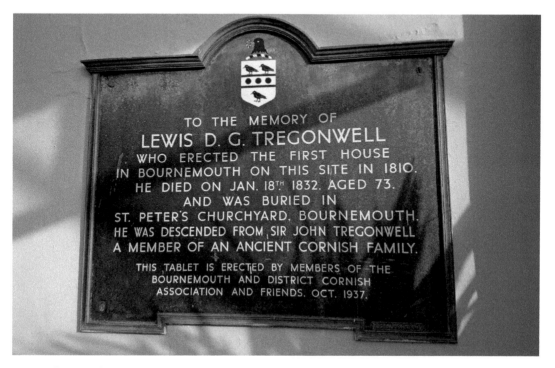

TO THE MEMORY OF
LEWIS D. G. TREGONWELL
WHO ERECTED THE FIRST HOUSE
IN BOURNEMOUTH ON THIS SITE IN 1810.
HE DIED ON JAN. 18TH 1832. AGED 73.
AND WAS BURIED IN
ST. PETER'S CHURCHYARD. BOURNEMOUTH.
HE WAS DESCENDED FROM SIR JOHN TREGONWELL
A MEMBER OF AN ANCIENT CORNISH FAMILY.

THIS TABLET IS ERECTED BY MEMBERS OF THE
BOURNEMOUTH AND DISTRICT CORNISH
ASSOCIATION AND FRIENDS. OCT. 1937.

A plaque at the Exeter Hotel.

Bournemouth started to develop into a seaside village for the genteel and elderly; then in 1841, Dr A. B. Granville, author of *The Spas of England*, was invited to visit this up-and-coming sea-watering place in order to give his professional opinion. He was highly impressed and stated that 'no situation that I have had occasion to examine along the whole southern coast, possesses so many capabilities of being made the very first invalid sea-watering place in England' (*see also* Miscellaneous, Granville Chambers).

Sir James Clark, physician to Queen Victoria, was also impressed. He pronounced, 'there can be no doubt that Bournemouth deserves a place among our best climates and affords a very favourable winter residence'.

By 1851, these endorsements had put Bournemouth well and truly on the map, and shops sprang up accordingly, catering for the fashionable visitor and for the needs of invalids.

Did You Know?
The Bournemouth town motto is *Pulchritudo et Salubritas*, which means 'Health and Beauty'.

The first shops in Bournemouth were situated near the earliest villas in Westover Road. They catered for the fashionable and discerning visitor and this is still reflected in some of the shops there today.

This building on the corner of Westover Road, which is currently Prezzo's and was previously the pub Poets Corner, is a good example of an early Westover Road villa.

Bournemouth continued to prosper as a residential town for the well heeled, but when the railway arrived in 1870, the hoi polloi also flocked to spend time on the beach and bathe in the waters for good health. This coincided with the appearance of sea bathing machines and donkeys on the beach.

The construction of the pier in 1880, at the point where the River Bourne flows into the sea, signified a commitment to become a holiday resort to rival Brighton and Weymouth, and accordingly, the town is now a lively cosmopolitan seaside resort, which with Poole to the west and Christchurch to the east forms a sprawling conurbation of 465,000 people.

Did You Know?
Bournemouth was originally in Hampshire, but boundary changes in 1974 saw it become part of Dorset. The original County Gates marked the border between Dorset and Hampshire, but now the County Gates roundabout signifies the boundary between Poole and Bournemouth.

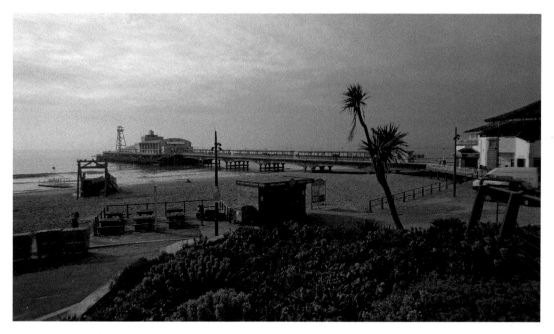

Bournemouth Pier.

# 1. Smugglers

By the late seventeenth century, the unlawful trade of smuggling was becoming widespread in England, and from the sixteenth to the nineteenth centuries, peaking between 1770 and 1815, the coastline around Bournemouth abounded with smugglers, mainly due to the ideal prerequisites of a long shoreline and a lack of prying eyes.

The imposition of duty on imported goods, to finance expensive European wars, significantly raised prices beyond the pocket of many, so it was a widely held view among the populace that there were extenuating circumstances to these activities.

By the 1850s, the effect of the return of peace after the Napoleonic Wars, along with more efficient customs, and tax reductions all but destroyed the practice. Another factor in the decline of smuggling was the introduction of the coast guard in the 1820s, which increased the risk of being caught.

Long before the upstart town of Bournemouth came into existence, the area consisted of a series of hamlets scattered around a vast heathland. One such hamlet was Kingston (now Kinson), which was a veritable nest of smugglers. Another nearby hamlet of a similar ilk was Longham, and both hamlets loomed large in the life of serial smuggler Isaac Gulliver, who operated around the mouth of the Bourne, long before the Tregonwells arrived.

Smugglers Cove Golf Course entrance.

Smugglers Cove Golf Course in the pier approach area of Bournemouth gives tourists a little bit of an insight into Bournemouth's secret past.

## Isaac Gulliver

Kinson has a colouful smuggling history, mainly due to the nefarious activities of Isaac Gulliver (1745–1822), who had up to fifty local people working for him.

He was the area's most celebrated and successful smuggler, but was actually born in Wiltshire. He was the son of a smuggler and married into a smuggling family.

In the late 1770s, he moved from Wiltshire to the White Hart Public House at Longham and then to West Howe House in Kinson, from where he controlled a massive smuggling operation which spread its tentacles across the whole of Dorset, Devon, Wiltshire and Hampshire.

West Howe House was demolished in 1958 and was found to be riddled with smugglers' tunnels, secret doors and hidden recesses. One door even led to a hiding place which was 10 feet up in the chimney. The house next door was called Woodlands and was thought to be haunted. When that was demolished in 1963, a man's skull was found, with a marlin spike, used for splicing knots, embedded in it.

Gulliver became a wanted man after his involvement in a clash with customs officers between Bournemouth and Poole. However, he regularly evaded their attention, and on one occasion was secreted out of the King's Head in Poole, hidden inside a barrel, under the very noses of customs officials. On another occasion, he eluded customs men by lying motionless in a coffin with his face covered with white powder as he played dead.

He even had the brass neck to provide his men with a kind of smuggling uniform which consisted of smocks and whitened hair – hence their nickname the 'white wigs'.

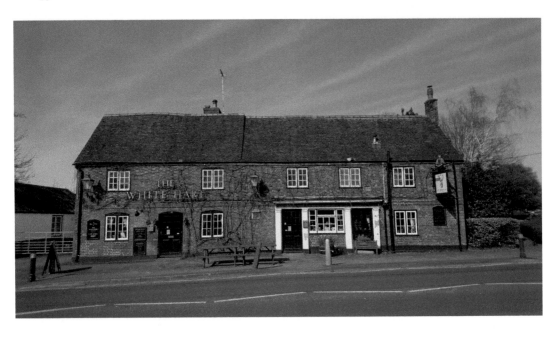

*Above*: The White Hart in Longham is 350 years old and at one time was owned by Isaac Gulliver, who also lived there for a period.

*Left*: Pug's Hole.

He had a fleet of fifteen luggers, from which his men would unload the contraband on the coastline. What couldn't be transported immediately was concealed amongst the furze bushes and pines. The rest was transported up through the chines with the aid of packhorses, before being moved across the heathland, where certain places were used as holding areas.

An example of a holding area for smugglers contraband is Pug's Hole on Talbot Heath, close to Talbot Heath Girls' School. It is said to be haunted by the spirit of a deceased smuggler, Captain Pug, who gave his name to this area. It is also reputed that a black dog-like creature haunts the area.

Another theory relating to the name of the area is that the name 'Pug' comes from the old name 'Puck', meaning meddlesome spirit. Indeed, there is another small woodland called Puck's Dell near Kinson.

Pug's Hole was once barren heathland, but was planted with pines around 1816, and is now a compactly wooded gorge, which forms part of the Talbot Heath section of the Bourne Valley Nature Reserve. It is a remnant of the ancient heath which once occupied the land between Christchurch and Dorchester.

Gulliver's smugglers would move the contraband from the various holding areas before it was distributed by his fleet of horse-drawn wagons, as far afield as the Midlands, London, Bristol and Bath.

A lot of the contraband was also stored in Kinson, where Gulliver and many of his fellow smugglers resided.

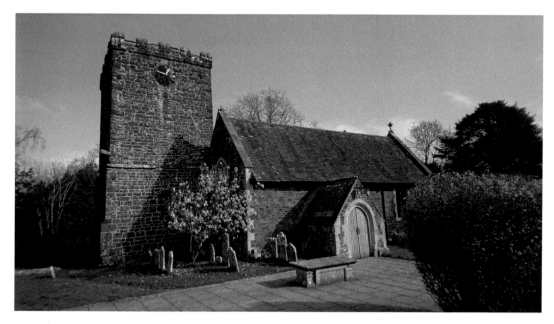

The tower of St Andrew's Church in Kinson was one of the places used for storing contraband. The ledges of the parapet of the tower have been damaged by the frequent hauling up of kegs and other contraband with ropes. The Grade II listed church building is centred on the site of a Saxon church, and has a Norman tower.

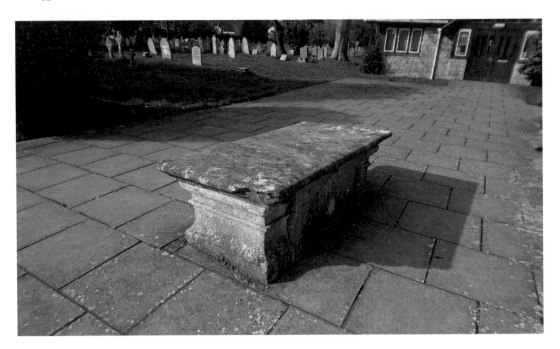

*Above*: A tomb by the main door of St Andrew's Church was used to hide contraband and it was said that only the initiated knew how to open it.

*Left*: In 1815, Isaac Gulliver, along with his wife and daughter, moved to Kinson House. The original house has gone and the location is now occupied by flats facing onto the Wimborne Road. The memorial to Gulliver at the front of the flats also celebrates a hundred years of council housing.

Gulliver owned 390 acres of land in the Kinson area. He bought up several houses and converted them for smuggling purposes, which involved equipping them with many suitable hiding places for contraband. He also instigated the building of a network of tunnels, which still undermine the whole of Kinson. One is said to lead from Kinson House, where he lived, to St Andrew's Church.

Kinson House had a concealed trapdoor in the dining room which led to a large cellar from which further tunnels led.

Having amassed a tidy fortune, Gulliver eventually retired from smuggling and was given a King's Pardon by George III. This was believed to have been because he discovered a plot to assassinate the monarch, and alerted the authorities. A grateful George III is supposed to have said 'let Gulliver smuggle as much as he wants', which may explain how he was never caught and was able to smuggle with impunity. Others say it was because he was given a chance in 1784 to wipe the slate clean by providing two of his men for active service in the Royal Navy.

His last landing of contraband is said to have been near where Bournemouth Pier now stands.

He then became a wine merchant (although it was believed that a large proportion of his wine was of the smuggled variety), banker, civic leader and churchwarden in Wimborne, and upon his death was buried in the vault of Wimborne Minster.

Although he was a powerfully built man, he was considered a gentleman, and it is claimed his pistol, which now resides in the Russell-Cotes museum in Bournemouth, was never used.

The house where Isaac Gulliver lived once his smuggling days were over.

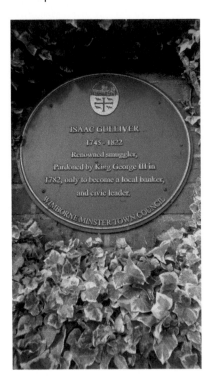

*Left*: A plaque at Isaac Gulliver's house.

*Below*: Pelhams House: Isaac Gulliver owned Manor Farm, which was previously called Kinson Farm and included Pelhams House. There is a road nearby called Manor Farm Road.

His legacy still lives on in Kinson and throughout the local area.

Gulliver's daughter Elizabeth finally managed to break the mould of that family and marry someone from outside of the smuggling fraternity. She married a respected banker, William Fryer. They lived in Pelhams House, which became Kinson Community Centre in the 1950s.

Elizabeth Fryer is buried in the Fryer Vault, which once resided within the church, but is now covered by an important and substantial monument, at the rear of the church.

Isaac Fryer, Gulliver's grandson, later lived at Kinson House, which then passed to his daughter Ada Russell.

## Robert Trotman

Robert Trotman originally came from Wiltshire, as did the man he worked for.

He was buried in St Andrew's Churchyard, Kinson, having been shot by customs men in 1765 during a fierce battle in which twenty smugglers were discovered loading a consignment of tea onto horses on the shore between Poole and Bournemouth.

The first customs man to arrive on the scene, Robert Wilson, was severely beaten by the smugglers with horse whips. The next to arrive, Edward Maurice, suffered the same type of treatment and was also wounded by a pistol shot. The smugglers then threw him into the sea and left him for dead, although he managed to struggle to safety and hide in a chine.

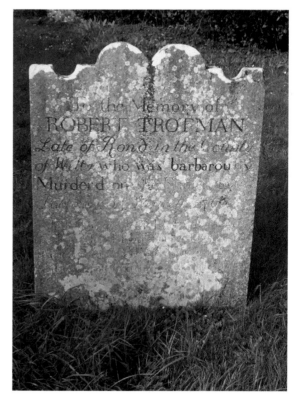

Robert Trotman is buried in St Andrew's Churchyard, Kinson. The inscription on the headstone reads:

Robert Trotman, barbarously murdere'd by the Revenue 1765:
A little tea one leaf I did not steal.
For guiltless blood shed. I to God appeal.
Put tea in one scale, human Blood in t'other.
And think what tis to slay thy harmless Brother.

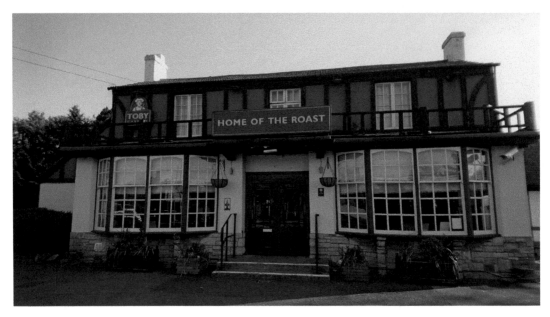

The Toby Carvery in Northbourne was formerly Ensbury Vicarage.

The skirmish continued and the smugglers also shot another customs man in the leg. The revenue men eventually gained control and ordered the smugglers to cut down the bags of tea from their horses and hand them over. By then, nine of the smugglers' horses had been killed and also the gang's leader, Robert Trotman.

Adjacent to Kinson in Northbourne there is a Toby Carvery, which was Ensbury Vicarage in a previous incarnation.

Nearby is a former Dower House, which is now privately owned and is a Grade II listed building. A Dower House is a property related to a Manor House, which was often inhabited by an elder son after his marriage, or simply rented to a tenant.

The original Manor House was called Ensbury Manor, and was demolished in 1936. It was next door to the vicarage (now Toby Carvery).

All of these properties were reputed to be involved in smuggling during Isaac Gulliver's day and the Manor House was said to be haunted.

## Other Smugglers Known to Be Buried at St Andrew's Churchyard

The ghosts of local smugglers are said to haunt the churchyard of St Andrew's Church, and there is certainly plenty of them lying within.

James Abraham
James Abraham spent time in Dorchester gaol after being convicted of smuggling in 1809.

Luke Budden
Luke Budden was baptised at St Andrew's Church. He was convicted of smuggling in 1828, aged nineteen, and spent time in Dorchester gaol.

Richard Frampton
Richard Frampton was born in 1803 and spent time in gaol after having been convicted in 1827 of making a light on the shore to aid smuggling. He was the last smuggler to be buried in the churchyard.

John Singer
John Singer was known to be one of Gulliver's longest-serving lieutenants and on one occasion in 1780 customs men found 541 gallons of brandy and rum and 1871 pounds of raw coffee in his Kinson granary. He was buried at St Andrew's Churchyard in 1781.

Henry Tiller
Henry Tiller was convicted of smuggling in 1826, and spent time in gaol. Afterwards he married and settled down at Tiller's Plot, East Howe. He was baptised, married and buried in St Andrew's Church.

## Other Smugglers Known to Have Been Active in Kinson
William Harris
William Harris was reputed to have been born at the smugglers den known as Decoy Pond House, Bourne Mouth (see Decoy Pond), and married at St Andrew's Church in 1756.

He was also believed to have been involved in the Battle of Mudeford in July 1784, which was a skirmish between smugglers and customs officers near Mudeford Quay. The battle resulted in the death of a customs officer and the subsequent trial and execution of one of the smugglers.

On another occasion, he was implicated in what was known as the Ansom Cutter Incident near Boscombe beach in 1774, which was another clash between smugglers and men of the revenue.

Stephen Marshall
Stephen Marshall served time in prison after being convicted of smuggling in 1827. He was active around Kinson, but was believed to have lived in the Parley area and was buried in West Parley Churchyard.

## Smugglers Associated with Public Houses in the Kinson Area
Isaac Gulliver lived the majority of his life in Kinson, where there used to be a pub called Gulliver's Tavern, which is now called the Acorn.

The pub was originally called the Dolphin, after the boat of the same name owned by Gulliver. It then became Gulliver's Tavern, before being named the Acorn.

As Gulliver's Tavern, it obviously referred to Isaac Gulliver, but was also a reference to the well-known book *Gulliver's Travels* by Jonathan Swift, in which Gulliver, a sea captain, travels to a land called Lilliput – incidentally there is an area of Poole named Lilliput after this fictitious place where the men are six inches tall!

It is the oldest public house in Bournemouth dating to around 1750. However, the fireplace is even older. Some say the pub is haunted, and there was a story in the 1980s of people hearing the sound of clinking, which turned out to be a ghostly figure sitting on a chest counting gold coins.

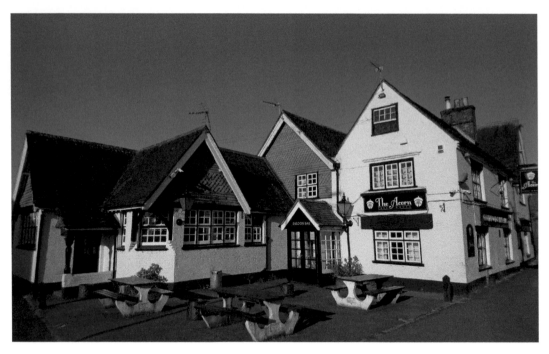

The landlord was originally from the Royal Oak that was across the road – hence the name.

John Potter
John Potter was known to be involved in smuggling, and owned the Dolphin Inn at one time. He also farmed at Howe Farm, which is now Kinson Common.

Edward Moores
Edward Moores was a well-known smuggler who was also once the landlord of the Dolphin.

Robert Hart
Robert Hart was connected with the White Hart Inn at Longham, as was Isaac Gulliver, who owned the premises and lived there for a period.

## Incident on 19 February 1784
Customs men under the command of William Lander went to Kinson in order to investigate reports of concealed contraband in a barn and stable.

On arrival, the search party were severely beaten by men armed with pistols, cutlasses, bludgeons and pitchforks. Miraculously no one died.

The customs men reported the presence of known smugglers: John King, the leader of the gang; John Dolman; William Butler; William Russell and his son John Russell; Jo Gillingham; John Sanders; Robert Brine; and Hannah Potter, the Dolphin Inn keeper's (John Potter) wife.

## Bourne House

Before Lewis Tregonwell built his house in 1810, there were only three buildings on the barren heathland. One was known as Bourne House or Decoy Pond House. It was associated with the Decoy Pond on the Bourne Stream and was situated where Debenhams is now. The pond itself was situated between where the war memorial in the Central Gardens now stands and Bournemouth Square.

It is believed that the building was originally a pair of semi-detached cottages built in the 1750s by the Clerk family who owned the land before George Tapps purchased it in 1778.

Decoy ponds were popular in England at this time. They were artificially created or modified pools of water which lured ducks and other wildfowl to be trapped and killed for food and feathers. Wildfowl caught in this way could be sold at a higher price, as it didn't contain lead shot.

The pond consisted of a central pool from which a number of small streams known as pipes emanated. They became progressively narrower and had nets over the top. The building would have accommodated the decoy man and the necessary equipment.

Ducks are naturally curious and will follow a predator such as a fox whilst keeping a safe distance. So the decoy man would use a dog in the same way to lure the ducks into the pipes.

The house was also believed to have been frequented by smugglers and used for storing contraband.

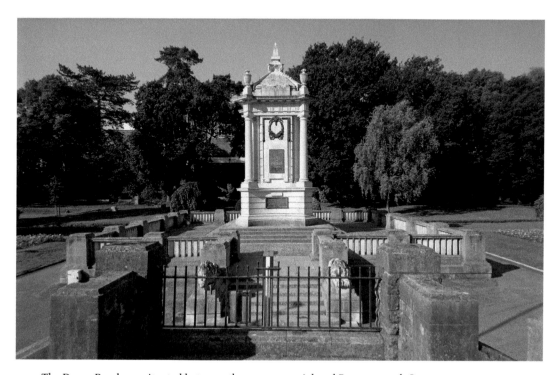

The Decoy Pond was situated between the war memorial and Bournemouth Square.

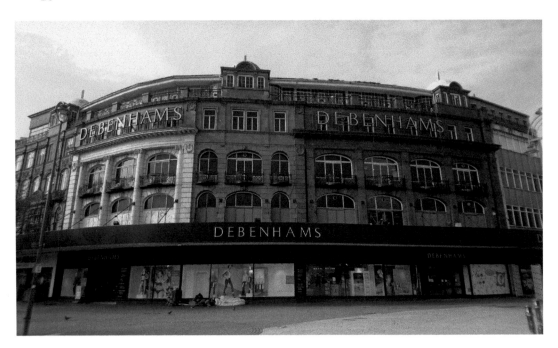

*Above*: The site of Bourne House/Decoy Pond House is now occupied by Debenhams.

*Left*: The Decoy Pond was situated in an area between the war memorial and the Square in what is now the Central Gardens.

## Coy Pond

After the demise of the Decoy Pond, Coy Pond was created in 1888 further up the Bourne Stream where the Upper Gardens become Coy Pond Gardens.

Although plenty of ducks and wildfowl are enticed to Coy Pond and the name refers to the former Decoy Pond, it was never a decoy pond and has never been used for their entrapment.

In fact, the pond is frequently used by wedding photographers to provide an attractive background for the happy couple.

Did You Know?
The source of the Bourne Stream, from which Bournemouth takes its name, is at Coy Pond, which is actually in the borough of Poole.

Coy Pond.

The Bourne Stream flows through the Upper and Lower Gardens, where it joins the sea at Bournemouth Pier.

# 2. Sporting Trivia and Hall of Fame

## Athletics

### Charles Bennett

Charles Bennett (1870–1948), a former landlord of the Dolphin Inn, Kinson (*see* Smugglers), was Britain's first ever Olympic track gold medallist, winning the 1500 m at Paris in 1900, and creating a world record of 4 minutes and 6.2 seconds in the process.

He was born and brought up in the Dorset village of Shapwick, not far from Bournemouth, and was a twenty-nine-year-old train driver when he won Olympic gold.

His early training in Shapwick involved chasing horses across ploughed fields, but he later became a member of Portsmouth Harriers, before moving to Finchley Harriers (now Hillingdon Athletic Club), where he started to win medals.

He became the licensee of the Dolphin in 1903 and lived across the road at Holt Lodge with his wife and five children, who all attended the Old Kinson School. His accommodation was next door to Isaac Gulliver's old dwelling, Kinson House.

He died in 1948 aged seventy eight whilst he was still the landlord at the Dolphin and is buried in St Andrew's Churchyard, Kinson.

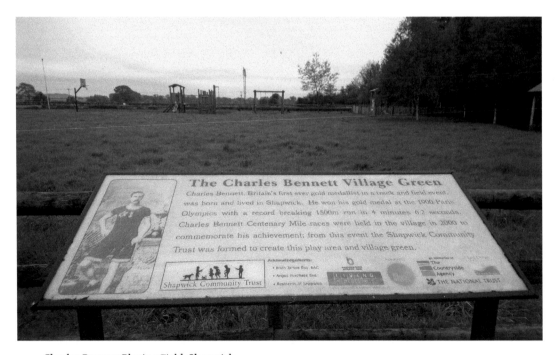

Charles Bennett Playing Field, Shapwick.

A hundred years after he won his gold medal, Bournemouth Athletic Club approached Shapwick Community Trust and asked if they could organise a Charles Bennett Millennium Mile Race around the village, to coincide with the start of the Sydney Olympics in 2000.

As a curtain raiser to the event, an athlete dressed as Charles Bennett ran the course carrying a replica Olympic torch. Participants came from all over the country, but they hadn't reckoned on Charles' athletic ancestors still living in the village; and fittingly, the boys' race was won by Charles' great-great grandson, Samuel Ward.

The funds generated by the event contributed greatly to the Shapwick Community Trust's efforts to open the Charles Bennett Play Area and Village Green in his honour, and the Charles Bennett Millennium Mile Race has been a regular event since.

## Boxing
### Freddie Mills
Freddie Mills (1919–65), the Bournemouth Bombshell, was world light heavy weight boxing champion from 1947 to 1950. He was born in Terrace Road, right in the town centre, and was based there whilst training for his early fights, which were in the town.

He had a colourful career after boxing, which included owning a Soho nightclub. This brought him into contact with the Krays and other unsavoury characters. He became heavily in debt, and was found shot dead in his own car outside the nightclub in 1965, aged forty-six. The death was recorded as suicide, but other theories have implicated Chinese gangsters.

There was a memorial to him in the Lower Gardens, which was removed in the late 1980s after it fell into a state of disrepair.

## Cricket
Dean Park, Bournemouth, was designed by Christopher Creek (*see* Miscellaneous), and was originally provided by Mr S. E. Cooper Dean, the same benefactor that provided facilities for AFC Bournemouth.

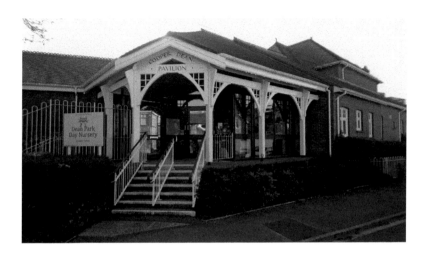

Dean Park Pavilion.

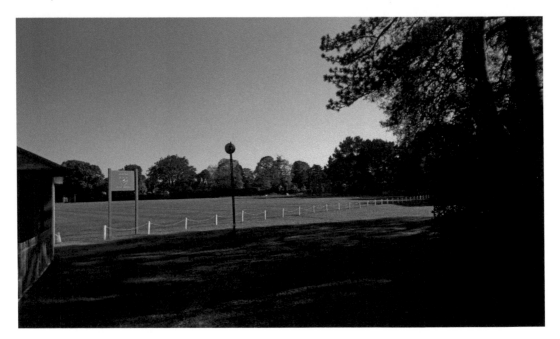

Dean Park Cricket Ground.

Cricket has been played at the venue since 1869, and from 1897 was a county ground for Hampshire. This continued to be the case for eighteen years after Bournemouth moved into Dorset as a result of the boundary changes in 1974.

The ground has even staged international cricket in the form of a women's one-day international between England and Australia, during the inaugural Women's World Cup of 1973.

After Hampshire left, the ground was used by Dorset County Cricket Club, who play in the Minor Counties Cricket Championship, Bournemouth University, Parley Cricket Club and Suttoners Cricket Club.

In 2014, the venue was bought from Cooper Dean Estates by Dean Park School.

## Football
### Beefy Makes His Debut at Bournemouth
A popular trick pub quiz question is to name three England captains who have played for Scunthorpe United Football Club: Kevin Keegan; Ray Clemence; and the one which will catch a lot of people out, Sir Ian Botham, who of course was England cricket captain rather than England football captain.

Even more people would be caught out by the fact that Botham made his football league debut for Scunthorpe United at Bournemouth, when he came on as a substitute in a Fourth Division game on Tuesday 25 March 1980.

His main aim in training with Scunthorpe was to keep himself fit over the winter months prior to England's winter cricket tour to the West Indies; but after playing a few

games for the reserves, he proved himself as a more than capable player, and coach John Kaye recommended him to first team manager Ron Ashman.

The press got wind that Botham would be on the subs bench at Dean Court, and large numbers of photographers arrived for an otherwise run of the mill fixture with little at stake for either team, watched by a crowd of fewer than 3,000.

When Botham did eventually enter the field of play after fifty minutes, the press, photographers and TV cameramen could barely contain themselves, often straying onto the pitch as the game was in progress.

Shortly after his arrival, Bournemouth scored, stretching their lead to 3-0. However, anyone familiar with Botham's exploits on a cricket pitch will not be surprised to learn that he then sparked a dramatic Scunthorpe fight back, where they scored three goals in eight minutes to make the final result a 3-3 draw – the sort of script only Beefy could write, with press headlines such as 'Bionic Botham' (*The Sun*) and 'Beefy Botham is a Super Sub' (*The Mirror*).

Despite reservations from the cricket authorities on the wisdom of Botham playing league football, his exploits the following summer of 1981 against Australia, in what are simply now known as 'Botham's Ashes', suggest the experience didn't do him any harm.

He made seven appearances for Scunthorpe in the Football League, with a further four as substitute. He was also a regular fixture in the Central League for Scunthorpe Reserves, once scoring a hat trick against Blackpool.

He later played for Yeovil Town who were then in the Gola League outside of the Football League.

*AFC Bournemouth v Leeds United, 5 May 1990*
This game was a culmination of an intense promotion race, as Leeds United sought to regain their First Division status after nine years.

The local police authority had made numerous requests to the Football League to alter the date of the fixture, as the timing of the match on a bank holiday weekend in conjunction with Leeds United's notorious hooligan element was always a recipe for disaster. The requests were ignored by the football authorities and the game went ahead as scheduled, on a sweltering bank holiday weekend.

Sure enough the town was invaded by hordes of drunken yobs that caused serious disorder in the town before the match. After the game, they invaded the pitch, before rampaging through the streets and beaches of Boscombe and Bournemouth.

104 arrests were made and twelve police officers were seriously injured as £40,000 worth of criminal damage was done.

## Horse Racing and Greyhound Racing
In 1919 Frederick Etches, a pioneer pilot, created an aerodrome at Ensbury Park on a site that had previously been used to train pilots for the Royal Flying Corps (*see* Wartime and Aeronautical Events). Then rather incongruously, in April 1925, a racecourse was also incorporated, along with a grandstand.

The co-owner of the racecourse was a colourful character by the name of Sir Henry 'Jock' Delves Broughton. Sixteen years later, he was acquitted of murdering his wife's lover, in Kenya –the 1987 film *White Mischief* is based on this story.

In January 1928, greyhound racing was also introduced, prompting the National Hunt Committee, the governing body that runs horse racing, to issue a statement to the effect of: 'Permission to stage horse racing would be withdrawn, unless greyhound racing was discontinued'. Therefore in February 1928, the last greyhound race took place whilst horse racing continued.

However, the flying tragedies at Whitsun of that year (*see* Wartime and Aeronautical Events) marked the beginning of the end for Ensbury Park as an aerodrome and racing venue and within two years the site was handed over to developers for housing. Now the only surviving link with the venue is provided by two of the road names: Etches Close and Broughton Avenue.

Greyhound racing later took place at nearby Victoria Park.

## Ice Skating

One of Bournemouth's best attractions was the former Westover Road Ice Skating Rink. It was a favourite venue in the town for sixty years.

The rink was built in 1930 above the showroom of Westover Motors, whose owner wanted his children to learn to skate. It was in use continually, apart from the war years, until 1991, when the owners decided it was no longer viable. The premises then lay empty for twenty-five years before finally becoming a gym.

1976 Olympic gold medallist John Curry made his professional debut here, and another gold medallist, Robin Cousins, learnt to skate here whilst on a family holiday from Bristol. He later performed here as a professional, as did Torvill and Dean.

## Surfing

The artificial surf reef at Boscombe was the first surfing reef to be built in Europe, and was built as a focal point for the seafront redevelopment at Boscombe.

At the time, Bournemouth Council stated, 'The reef will give Boscombe beach its own identity, raise the profile of Boscombe and attract a large number of visitors.' However, the innovative idea became one of the most expensive project failures ever seen on the south coast.

Construction work began in June 2008, but after many lengthy delays the reef did not open until November 2009. The project cost hundreds of thousands of pounds, but this did also include turning a car park into beach pods (beach hut-type arrangements which you can sleep in), the Honeycombe Chine Flats complex and the redevelopment of the seafront.

To add insult to injury, the large waves that were promised simply never materialised, and surfers rarely used it.

Then in August 2011, one of the giant sandbags from which it was constructed broke, necessitating closure for safety reasons whilst the company behind the project ASR from New Zealand undertook repairs. However, by September 2012, ASR went into liquidation and repair work still hadn't been completed.

By September 2013, the reef was still in a state of disrepair, meaning the council had to undertake the work themselves.

Surfers attempting to enjoy the unenhanced waves at Boscombe Pier.

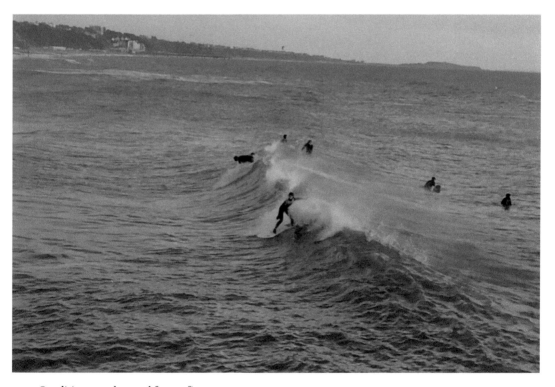

Conditions can be good for surfing.

Although the reef was a total failure, as far as surfing was concerned, it did form part of a regeneration project which attracted businesses to the seafront, and helped to give the area a lift.

## Swimming

Bournemouth's first swimming pool opened in 1838 and was subsequently replaced by another pool which marked Queen Victoria's Golden Jubilee in 1887.

Then in 1937 the Pier Approach Baths opened and quickly became far more than just a swimming pool. They featured numerous competitions and exciting sports such as water polo; but for most people, locals and tourists alike, the highlights were the Aqua Shows, which were regular events throughout the 1950s and '60s. They featured Brian Phelps, who was an Olympic high diving bronze medallist in 1960 and Commonwealth gold medallist in 1962 and 1966.

The Pier Approach Baths closed in 1984 and is another greatly missed institution. It made way for the redevelopment of the Pier Approach area, which involved Bournemouth Council selling the building to help finance the Bournemouth International Centre (BIC).

After much delay, the controversial Imax cinema complex opened at the site in 2002, which was a great success in blocking the view of the seafront and the Purbecks. This was eventually demolished to make way for a more open Pier Approach, which was completed in early 2018, and now includes the Smugglers Golf Course (*see* Smugglers).

The view that the Imax blocked.

*Bournemouth Spartans*

You have to be tough to be a Bournemouth Spartan. They are a club which advocates swimming in the sea throughout the year, and are based at Boscombe Pier. Only those who have completed twenty-eight swims during the winter are permitted to wear the prestigious Spartan badge.

The highlight of their season is the annual White Christmas dip, which involves diving into the freezing waters in aid of Macmillan Cancer Support. Naturally, the wearing of festive fancy dress is obligatory.

The event has been taking place since 2007 and was initiated by Tom Baker, whose uncle was cared for by Macmillan Cancer Support.

*Pier to Pier Swim*

Another big charity event which has been in operation since 1990 takes place on the seafront, and involves thousands of people swimming the 1.4 miles between Bournemouth and Boscombe piers in aid of the British Heart Foundation.

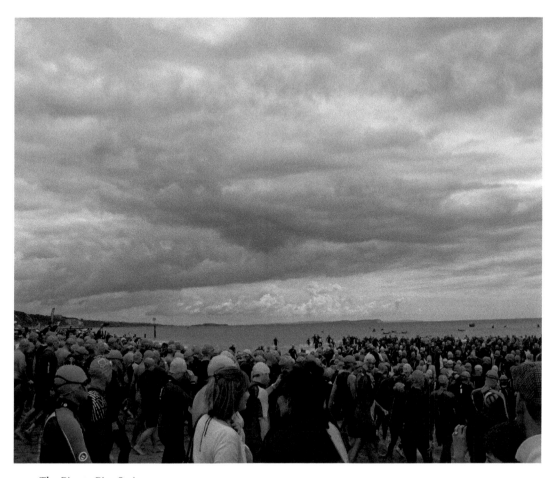

The Pier to Pier Swim.

## Tennis

The West Hants Lawn Tennis Club in Roslin Road, Bournemouth, was the home of the annual British Hard Court Championships.

The inaugural tournament was held at Torquay in 1924, but the competition moved to the West Hants Club in 1927, and remained there until 1983. Then in 1995, the tournament was revived in Bournemouth as a ladies only tournament, but was only played for that one year.

In its pre-war heyday, the tournament was regarded as one of the major world tournaments. It was one of the most important events outside of the Grand Slams, and as far as British tournaments were concerned was secondary only to Wimbledon.

Fred Perry's record of five consecutive titles in the tournament from 1932 to 1936 is unsurpassed. However in 1968, Britain's Mark Cox became the first amateur player to beat a professional player in an open tournament, and then in the same year, Britain's Virginia Wade actually won the tournament, as an amateur, meaning she had to return the prize money.

### Virginia Wade

Bournemouth-born Virginia Wade became the darling of Wimbledon in 1977 when she won the prestigious tournament in the Queen's Silver Jubilee year in front of Her Majesty.

In a stellar career she also won the American Open title in 1968, the Italian title in 1971, and the French Championship in 1972, as well as four Grand Slam Doubles titles.

Then in 1982 she made history by becoming the first woman to be elected to the Wimbledon committee, before becoming a tennis commentator.

# 3. Wartime and Aeronautical Events

Two incidents occurred in Bournemouth which could have resulted in very different outcomes to both World Wars. One could have resulted in the First World War not taking place; the other could have resulted in the Allies losing the Second World War.

## Incident 1

In the early 1900s, the future Kaiser of Germany was attempting to ford Millhams Splash, a small tributary of the River Stour in Kinson, whilst travelling in a carriage from Canford Manor to Highcliffe Castle. He became stuck in the mud, but luckily for him some helpful locals were on hand to free him. However, when the First World War started they wished they hadn't bothered.

## Incident 2

Winston Churchill described Alum Chine as 'a small wild place where forty or fifty acres of pine forest descend by sandy undulations to the smooth beach of the English Channel'.

It was at Alum Chine in 1892 that Winston, then aged eighteen, nearly lost his life. The incident occurred whilst the future prime minister was staying with his aunt Lady Wimborne at Branksome Dene.

The bridge at Millhams Splash.

Winston was playing a game of tag with his brother and cousin, and found himself on a bridge with nowhere to run as his companions closed in from either end. In a reckless moment Winston made an escape bid by attempting to jump onto a pine tree. He believed, in the foolhardiness of youth, that he would slide down the tree trunk as the stems of the minor branches slowed down his descent – rather like one might see in a comic.

Recalling the incident years later, he commented 'the argument was correct; the data absolutely wrong'. Very wrong. He plunged 30 feet and hit the ground like a sack of spuds. He was knocked unconscious and ruptured a kidney. He was unconscious for three days and had to convalesce for two months.

Fortunately for the nation he recovered sufficiently, and based his wartime strategies on much better intelligence.

This bridge, built in 1922, at Alum Chine replaced the wooden rustic bridge from which Winston Churchill jumped.

## War Damage

Bournemouth didn't receive the heavy bombing that the nearby south coast cities of Southampton and Portsmouth endured. However, the Luftwaffe frequently jettisoned unused bombs on the town before returning to Germany after bombing raids.

In total Bournemouth suffered fifty air raids, in which a total of 2,271 bombs were dropped, including incendiaries. The cost of the bombing was 219 killed, 246 premises destroyed and nearly 14,000 properties damaged.

The first German bombing raid on the town took place on 3 July 1940, when twenty properties were damaged in Cellars Farm Road, Southbourne.

Another destructive raid came on 16 November 1940, when six parachute mines were dropped on the Westbourne, Malmesbury Park and Alma Road areas. This raid destroyed Alma Road School, as well as famous author Robert Louis Stevenson's house Skerryvore (*see* Music, Literature and Entertainment).

The town suffered its largest and most damaging raid on 23 May 1943, when seventy-seven residents and troops lost their lives, thirty-seven buildings were destroyed and 3,481 buildings were damaged.

One of the most high-profile buildings to be damaged on the same night was Beales. Also hit were the Metropole Hotel (now the Christopher Creeke pub), the Central Hotel and Bobby's (now Debenhams).

In 1940, the central supports of the Bournemouth Pier were demolished by the Royal Engineers, rendering the pier unusable to a German invasion force. After the war, the pier was rebuilt and a theatre added.

## Pilot Hight

During the Battle of Britain, Cecil Hight, a New Zealand spitfire pilot flying with the RAF, was shot down over Bournemouth after his squadron was scrambled to intercept German bombers.

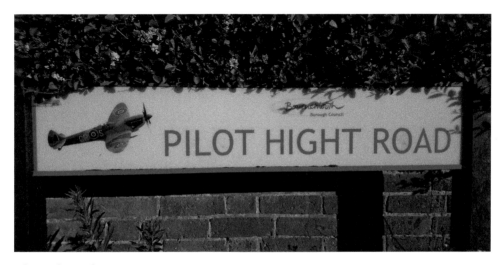

Pilot Hight Road.

His spitfire was downed by the rear guns of a German bomber. He ejected, but his parachute failed to open and the plane crashed at Leven Avenue.

Pilot Hight is thought to be the only allied airman killed over the town during the war. His memory is recognised by a memorial in St Peter's Church, and Pilot Hight Road in West Howe is also named in his honour.

Later in 2010, during the seventieth anniversary of the Battle of Britain, an image of a spitfire was added to the road sign after a Community Police Officer PC Rob Hammond succeeded in his quest to further recognise Cecil Hight, as a means of encouraging people to take pride and ownership of their neighbourhood.

## Bournemouth's Victoria Cross Winners

The statue of Captain Lewis Tregonwell of the Dorset Yeomanry (*see* Introduction) also features a scroll, which lists the names of Bournemouth's three Victoria Cross (VC) winners.

The amazing thing is that they all lived within a mile of each other. Frederick Riggs and Reginald Noble were both born in Capstone Road and Derek Seagrim was born round the corner in Charminster Road.

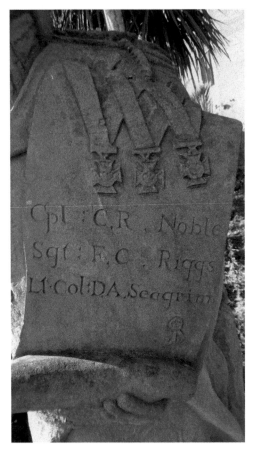

A closer view of Captain Lewis Tregonwell's scroll, featuring Bournemouth's VC winners.

*Sergeant Frederick Charles Riggs*

Frederick Charles Riggs was born on 28 July 1888, at the Sprinbourne end of Capstone Road. He was awarded the VC for his conduct at the Battle of Canal du Nord, France,

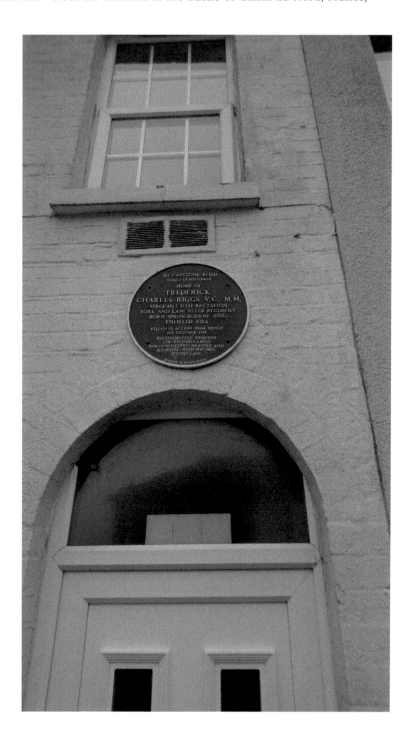

A plaque at the house that replaced the now demolished house of Sergeant Frederick Charles Riggs.

on 1 October 1918, during the First World War. He served in the York and Lancashire Regiment, and had previously won the Military Medal. The citation for his VC read:

> Having led his platoon through strong uncut wire, he continued straight on and although losing men heavily from flanking fire, he succeeded in reaching his objective where he captured a machine gun.
>
> Later he handled two captured guns with great effect and caused fifty of the enemy to surrender.
>
> Subsequently when the enemy again advanced in force, Sergeant Riggs cheerfully encouraged his men exhorting them to resist to the last and while doing so was killed.

## Cecil Reginald Noble

Reginald Noble was born on 4 June 1891 in Bournemouth and lived at No. 175 Capstone Road, attending Malmesbury Park Primary School, as it is now known. He was awarded the VC for his conduct at the Battle of Neuve Chapelle, France, during the First World War. He served in the Rifle Brigade (Prince Consort's Own). The citation for his VC read:

> On 12 March 1915, at Neuve Chapelle, when the advance of the battalion was impeded by wire entanglements and by very severe machine gun fire. Corporal Noble and another man (Harry Daniels) voluntarily rushed in front and succeeded in cutting the wires. They were both injured and Corporal Noble later died of his injuries.

Daniels survived to receive his VC and later rose to the rank of Lieutenant Colonel.

## Lieutenant Colonel Derek Anthony Seagrim

Derek Anthony Seagrim was born on 24 September 1903 at No. 14 Charminster Road, Bournemouth, but unfortunately, in what seems a major oversight, his birthplace and heroic conduct are not acknowledged in the town, apart from on the Tregonwell scroll. He was awarded the VC for his conduct at the Battle of the Mareth Line, Tunisia, during the Second World War. He served in the King's South African Rifles – Green Howards. The citation for his VC read:

> In October 1942, he was given command of the 7th Battalion the Green Howards at El Alamein.
>
> On 20/21 March 1943 at the Mareth Line, Tunisia. Lieutenant Seagrim's courage and leadership led directly to the capture of an important objective. When it appeared that the attack on a position would fail owing to the intensity of the enemy fire, he placed himself at the head of his battalion and led them forward. He personally helped to place a scaling ladder over an anti tank ditch and was the first across. Leading the attack on two machine gun posts, he accounted for twenty of the enemy and when a counter attack was launched next day he moved from post to post quite unperturbed until it was defeated.

He later died at a military hospital near Sfax on 6 April 1943, after being severely wounded at the Battle of Wadi Akarit.

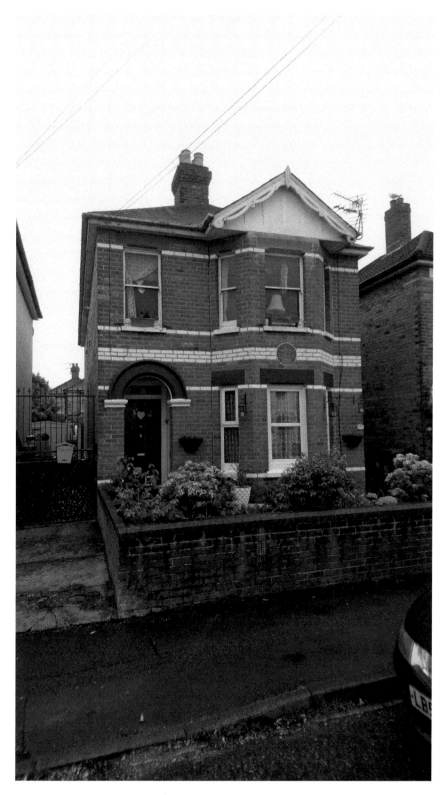

The house of Victoria Cross winner Cecil Reginald Noble.

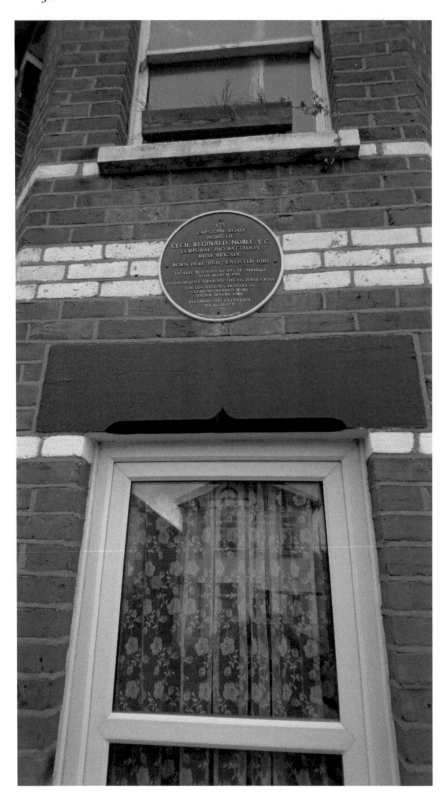

The plaque at the house of VC winner Cecil Reginald Noble.

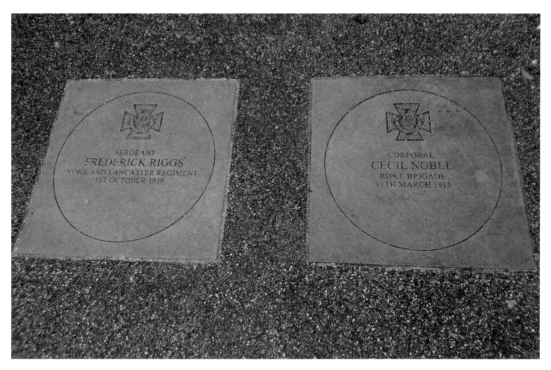

Commemorative paving stones adjacent to the war memorial in the Central Gardens.

His brother, Hugh Seagrim, was also awarded the George Cross, meaning that he and his brother hold the distinction of being the only siblings to be awarded both the Victoria Cross and the George Cross, both posthumously.

### Flying Hero

Another Second World War VC was won by a Bournemouth-based flyer operating from RAF Hurn (now Bournemouth International Airport). His name was Paddy the Pigeon, and he was one of thousands of messenger pigeons donated by pigeon fanciers to help the war effort.

Thirty pigeons, including Paddy, were specially selected for D-Day missions. They were delivered to RAF Hurn prior to being taken to France by a unit of the First US Army.

After his release at 8.15 a.m. on June 12 1944, he returned to RAF Hurn in a record-breaking time of 4 hours and 50 minutes with vital coded information on the Allied advance. This was the fastest time ever recorded by a message-carrying pigeon, and in appreciation of his outstanding contribution, Paddy was awarded the Dicken Medal, the animal equivalent of the Victoria Cross.

After the war Paddy was reunited with his owner in his home town of Carnlough, Northern Ireland, where he enjoyed a more peaceful time, until he died in 1954, aged eleven.

Paddy achieved recognition as a hero, but many of his brave pigeon comrades were killed in the line of duty as they flew through the dangerous skies to deliver their messages.

## The Unfortunate Demise of One Half of Rolls-Royce

Charles Rolls was one of the leading lights in the world of motoring and it was through the Royal Automobile Club that he met his business partner, Henry Royce, in 1904.

However, Rolls' overriding passion was for aviation in all its forms, and in 1909 he purchased one of six Wright Brothers aircraft, and became only the second Englishman to go up in an aeroplane. He then went on to make more than 200 flights and became the first man to make a double crossing of the English Channel by plane, on 2 June 1910. He was also an experienced balloonist who made over 170 assents.

He later came to an agreement with Henry Royce, enabling him to step back from his day-to-day involvement with the firm in order to focus on flying.

Shortly afterwards on 12 July 1910, he took part in an aviation meeting at Hengistbury Airfield, Southbourne (now St Peter's School), which formed part of Bournemouth's centenary celebrations.

Flying his Wright Brothers bi-plane, he attempted a pinpoint landing on a marked spot, but the tail snapped and the plane suddenly plummeted to earth. He was flung from the aircraft and killed instantly on impact.

A plaque in the playing field of St Peter's School, which was unveiled in 1981, marks the spot with the words:

> This stone commemorates the Hon Charles Stewart Rolls who was killed in a flying accident near this spot on 12 July 1910; the first Briton to die in a powered flight.

## Bournemouth Airport

Bournemouth International Airport began life during the war as RAF Hurn in 1941, and was used by both the Royal Air Force (RAF) and the United States Army Air Forces (USAAF). It housed both transport and fighter aircraft including Spitfires, Wellingtons and Typhoons. It was initially a satellite station to nearby RAF Ibsley, but became a main base after extending its runways.

Towards the end of 1942, the base passed to American control and became USAAF Station AAF-492, and was home to P-61s of the 422 Night Fighter Squadron. Subsequently the base went on to become instrumental in the development of the use of radar in bombers and fighter bombers supporting the D-Day invasion.

It was handed back to the RAF after D-Day, in October 1944, and then transferred to the control of the Ministry of Civil Aviation after the war, when it became Bournemouth Airport. During this period, it was the main airport for international flights in Britain, until Heathrow opened in 1949.

In 1969, the airport was bought by Bournemouth Corporation and Dorset County Council, who owned it until National Express purchased it in 1995. It was then sold to Manchester Airports Group in 1999, who in turn sold it to Regional and City Airports, a part of Rigby Group PLC in 2017.

The airport also has a flourishing cargo trade, particularly with Jersey, which started in 1972 when Jersey tomato growers were desperate to salvage a large consignment that was stranded in Jersey during a lorry drivers' strike on the British mainland. In a bid to solve the problem they utilised Bournemouth Airport.

*Right*: Bournemouth Airport.

*Below*: Grounded planes at Bournemouth Airport in 2020 due to the Covid-19 pandemic.

Bournemouth Airport, via Bath Travel, was also one of the pioneers of package holidays, a feature of which was the gregarious managing director of Bath Travel, Peter Bath, personally greeting each passenger.

## Ensbury Park Aerodrome

In 1915, what is currently the main Bournemouth University site was the location of Bournemouth Aviation Flying School. The school was set up by Fred Etches, a pioneering aviator, to train First World War pilots for entry into the Royal Flying Corps (later to become the RAF).

The school prospered and trained some of the luminaries of aviation, including Alan Cobham, who later set up Cobham plc, one of the leading employers in the area.

In 1917, the flying school moved to an 88-acre site in what is now the Hillview Road and Redhill Drive area of Ensbury Park, before becoming RAF Winton.

In 1919, the RAF moved out, but the aerodrome remained and changed to civilian use. The transfer was marked by a display given by one of the First World War's legendary fighter pilots in a Royal Flying Corps Handley Page bomber. The pilot in question was Lieutenant Colonel William Sholto Douglas, who was renowned for his ferocious dogfights during the First World War, including one over France, with Hermann Goering, the future Commander-in-Chief of the Luftwaffe during the Second World War.

The airfield went on to provide a regular passenger air service between Bournemouth and Cricklewood in London, and then in 1924 it also began to be used for horse racing and greyhound racing, for which a grandstand was built (see Sporting Trivia and Hall of Fame).

The first air show took place at Easter 1927, and was disrupted by an enraged farmer disgruntled at the disturbance to his livestock. He fired a shotgun at the planes and narrowly missed one of the pilots.

The second air show was relatively uneventful, but tragedy struck on the third show at Whitsun 1927. Firstly a plane crashed killing the pilot on a trial flight; then later during the actual display two planes collided, killing both pilots, one of whom was the pilot who narrowly escaped being shot by the farmer at the first show. These tragedies marked the beginning of the end for Ensbury Park Aerodrome.

## Flying Boats

For a short period after the First World War there was a flying boat aerodrome adjacent to Bournemouth Pier, from where Supermarine Aviation operated flying boat services from Bournemouth to Southampton and the Isle of Wight.

## Air Festival

Bournemouth has been hosting an annual air festival since 2008. It is free to attend and is centred on the pier.

It attracts 1.5 million visitors, and features aircraft from the Royal Air Force, Royal Navy as well as civil aviation displays.

Some of the highlights include the Battle of Britain Flypast, featuring a Spitfire, a Hurricane and a Lancaster; the Vulcan; and of course everybody's favourite the Red Arrows.

The Red Arrows.

### Red Arrow Crash

On 20 August 2011, Flight Lieutenant Jon Egging 33, from Rutland, was killed when his Hawk T1 aircraft crashed in a field near the River Stour at Throop following a display at the Bournemouth Air Show.

Jon was coming to the end of his first year with the world-famous Royal Air Force aerobatic team the Red Arrows, where he flew in the position of Red 4, on the right-hand side of the famous Diamond Nine formation. All nine Red Arrows pilots are fast jet pilots from frontline RAF squadrons, and to be given such a demanding position was an honour not usually bestowed on first-year pilots.

### Flight Lieutenant John Green DFC

Next to Jon Egging's memorial is another one to flight Lieutenant John Green DFC, who was a Canadian wartime pilot with the RAF. The citation for Flight Lieutenant Green's Distinguished Flying Cross (DFC) stated:

> This Canadian officer joined his squadron on 12 October 1940 and carried out his first operation as a first pilot, on 16 October. On this occasion he flew through extremely difficult weather conditions and was one of four out of twelve aircraft to locate and attack enemy submarines at Bordeaux.
>
> On 20 November, this officer was captain of an aircraft detailed to bomb the Skoda works in Czechoslovakia which he attacked successfully from 1,500 feet causing fires and explosions.

The Jon Egging Memorial.

Pilot Officer Green's work as an operational pilot has been outstanding and his enthusiasm skill and courage have been a cause of inspiration to the newly joined flying personnel in the squadron.

He has completed a total of ten operational flights against the enemy during the course of which he has completed seventy seven hours flying as a first pilot.

His war ended when he was later shot down over Holland on 11 February 1941 and became a prisoner of war. He lost his life on 17 September 1947 when his Spitfire crashed into the sea between Boscombe and Bournemouth piers during a flying display in aid of the RAF Benevolent Fund and to mark the anniversary of the Battle of Britain.

# 4. The Amazing Rags to Riches Story of AFC Bournemouth

AFC Bournemouth may currently reside amongst the Premiership elite (2020), but it hasn't always been that way. They have certainly not been strangers to lower league relegation battles and great escapes. Not to mention the financial woes that have nearly seen them disappear from the face of the earth.

The club were formed in 1890, as Boscombe St John's Institute FC, and played in local football before becoming Boscombe FC in 1899.

As Boscombe FC, the club competed in the Bournemouth and District Junior League, and initially played at a ground in Castlemain Avenue, Pokesdown, before moving to King's Park adjacent to the current stadium in 1902.

They then joined the Hampshire League and were soon attracting big crowds. Then in 1910 Mr S. E. Cooper Dean granted the club a long lease on some waste ground in the vicinity of a number of cherry orchards next to King's Park. This became the club's home ground, and was named Dean Court after their benefactor. The cherry orchards account for the team's nick name, 'The Cherries'.

The club then moved into the South Eastern League, but progress was interrupted by the outbreak of the First World War in 1914.

Kings Park from where the floodlights of the current stadium are visible.

This building was once the Portman Hotel before it was converted into flats in 2017.

After the war in 1919, Boscombe FC had to return to the Hampshire League. Then in 1920, the Third Division was formed, which created gaps further down the leagues, enabling them to join the Southern League.

After three years in the Southern League, they were accepted for membership of the Football League and moved into the Third Division (South) in 1923. In fact Bournemouth still hold the record for the longest continuous membership of the Third Division.

Prior to the club starting in the Third Division, a meeting took place at the Portman Hotel, at which it was decided to change the team's name to Bournemouth and Boscombe Athletic FC. This was the same pub where the team used to change before matches. Portman was the maiden name of Henrietta, the second wife of Captain Lewis Tregonwell (see Introduction), known as the founder of Bournemouth.

After the Second World War in the 1945/46 season, the club won their first trophy as a league club, which was the Third Division (South) Cup. Their next piece of silverware came when they then had an exciting run in the 1956/57 FA Cup, beating Wolves 1-0, then Spurs at home 3-1, before losing to Manchester United 2-1 in front of a record crowd at Dean Court of 28,799. However, their efforts were not in vain, as they were awarded the Giant Killers Cup.

In 1970 the team were relegated to Division Four, but this heralded an exciting period under John Bond, with prolific goal scorer Ted MacDougal in the team. They won promotion in 1970/71, and then the following year the club changed its name to AFC Bournemouth.

Did You Know?
The AFC stands for Athletic Football Club, not Association Football Club as many people think.

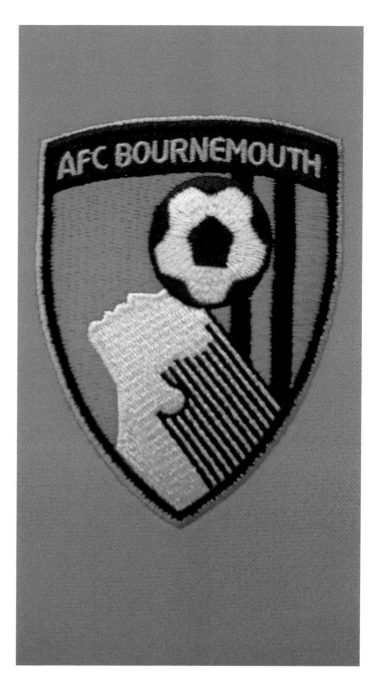

The AFC Bournemouth crest.

After both Bond and MacDougal left, the club began to struggle on the field and also off the field with debt, a combination that brought relegation in 1975. The following season, Alec Stock arrived as manager. He instilled some pride, which resulted in some improvement.

In 1982, David Webb gained promotion to Division Three, but he was sacked shortly afterwards following a dispute with the chairman.

Don Megson then took over and the club seemed to be spiralling downwards towards Division Four. However, the appointment of Harry Redknapp, then an unknown in the football management world, arrested the decline.

Harry endeared himself to the Bournemouth public early in his reign, when in January 1984 Bournemouth dumped the holders Manchester United out of the FA Cup. He then went on to build a team that stormed to the top of the Third Division in 1986/87 and gained promotion to the Second Division for the first time in the club's history.

However, they were relegated in 1990 on that notorious occasion when Leeds United 'fans' rampaged through Bournemouth (see Sporting Trivia and Hall of Fame).

## The First Great Escape – 1994/95 Season
Financial problems were beginning to bite at the start of the 1994/95 season, making life difficult for Tony Pulis, who was relieved of his position after losing the first seven games. He was replaced by Mel Machin, who had played for Bournemouth during the 1960s and '70s.

By the beginning of December, Bournemouth were adrift at the bottom and only had nine points. However, they were becoming harder to beat.

The situation gradually began to turn round, as they started to pick up sufficient points to give themselves a chance, meaning that ultimately, survival came down to the last two matches of the season against Brentford and Shrewsbury. A win at Brentford and favourable results elsewhere meant that Bournemouth could control their own destiny. Miraculously that did prove to be the case, and they subsequently beat Shrewsbury, meaning that through the slimmest of margins they had avoided the drop.

## The AFC Bournemouth Story Continues Against a Backdrop of Financial Uncertainty

The dire financial situation continued and in 1996, the receivers were called in.

No financial benefactor came forward, prompting supporters to organise a Trust Fund, which was led by Trevor Watkins, and on 18 June 1997, Bournemouth became Europe's first ever professional Community Club. It was only just in time, as the club was fifteen minutes away from closure. The club had won a reprieve, but their problems were far from over.

Despite the background of financial insecurity, the Cherries made the play-offs in the 1997/98 season and also the final of the Auto Windscreens Shield at Wembley. Then in 2000, record appearance maker Sean O'Driscoll took over as first team manager, and again, Bournemouth narrowly missed out on promotion to the second tier, losing in the play-offs.

## Jermaine Defoe 2000/01 Season

Sean O'Driscoll was aided and abetted by the goal-scoring machine that was Jermaine Defoe. He played for Bournemouth whilst on loan from West Ham, and the teenage prodigy showed the lethal striking ability that saw him win fifty-seven caps for England.

He scored in ten consecutive games for Bournemouth, and scored nineteen times in thirty-six appearances for the club.

## The AFC Bournemouth Story Continues Amidst More Financial Uncertainty

In 2001, the ground had to be completely rebuilt after being threatened with closure by the Football Licensing Authority due to the existence of three sides of terracing, which had been outlawed after the Hillsborough disaster in 1989 and the subsequent Taylor report of the same year.

The Cherries had to temporarily move out of Dean Court to ground share with non-League neighbours Dorchester while the old stadium was demolished and completely rebuilt, with the pitch rotated 90 degrees to increase the distance from local housing.

The new ground was unveiled on 10 November 2001, with Wrexham as the opposition.

> Did you know?
> The first goal scorer at the new Dean Court was Brian Stock.

Unfortunately the Cherries were relegated to the fourth tier on the final day of the 2001/02 season. However, the following season saw Bournemouth gain promotion via the play-offs and Peter Phillips become chairman.

In 2005 the club sold their ground to raise finance in a sale and leaseback deal with London property company Structadene.

Then in October 2006, Sean O'Driscoll departed, making way for Kevin Bond, son of previous Bournemouth manager John Bond.

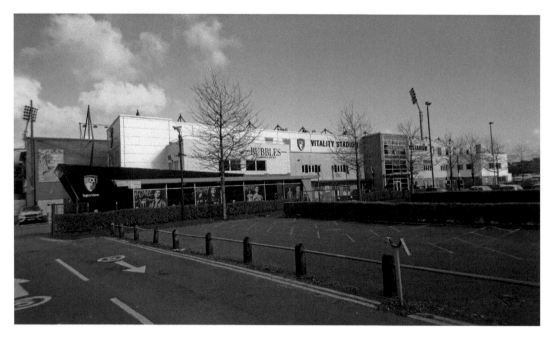

The AFC Bournemouth Stadium.

Bond's tenure, as with many before him, was beset by financial concerns. However he managed to avoid relegation in 2006/07, and the same season saw Jeff Mostyn appointed as chairman.

## The Greatest of Great Escapes Part One

On 2 February 2008, Bournemouth were in the relegation zone of League One (the third tier), having just managed to haul themselves to within one point of safety.

However, behind the scenes, the clubs mountain of debt had resulted in a winding-up petition being served on the club by HM Revenue and Customs Service, forcing chairman Jeff Mostyn to place the club in the hands of administrator Gerald Krasner, who was from a firm of business recovery experts based in Leeds.

To add insult to injury, the proverbial rug was pulled from under the club when they found they were in fact now eleven points from safety, having been docked ten points for going into administration. The very future of AFC Bournemouth seemed in doubt, and relegation looked a certainty.

However the team continued to battle on under club captain Darren Anderton. The ex-Tottenham and England player was in the swan song of his distinguished career, and he spearheaded the survival bid.

A 2-1 defeat at Gillingham on 22 March then put them fourteen points away from safety, but a win over Millwall meant that mathematically the team were hanging on by the barest thread. From this point the team, which due to a transfer embargo included seven youth team players, put together a brilliant run, which gave them a chance of an unlikely escape.

The culmination of the 2007/08 season boiled down to a must-win game away at Carlisle. The game ended in a 1-1 draw, which meant that despite the battling heroics of a young team, they were relegated on the last day to League Two (the fourth tier).

## The Greatest of Great Escapes Part Two

The club failed to resolve the financial mess during the close season and faced the prospect of liquidation. A pivotal press conference took place, live on TV, at which Gerald Krasner was about to deliver the news that AFC Bournemouth had finally run out of money, and would therefore be liquidated and cease to be a football club.

Before the meeting Gerald Krasner had said to Jeff Mostyn, 'One of two things is going to happen. Either you are going to give me a cheque for £100,000 today and you will be at the back of the room and you will nod; or when, I ask the question you will shake your head and I will liquidate the club on air.'

When it came to it Jeff Mostyn allowed his heart to rule his head and nodded, meaning he had to pay £100,000 of his own money to keep the club afloat for another four weeks.

The club were up for sale, but as buyers were not queuing up to take it on, Jeff Mostyn had to pay a further £500,000 that he didn't really have, just to keep the club from going under.

Eventually, Chester-based businessman Paul Baker and his company Sport 6 took over the club, and the Cherries were back in business. They came out of administration two days before the 2008/09 season started.

However the devastating news then came through that Bournemouth would have seventeen points deducted, due to their financial position. Rotherham were also deducted the same amount, whereas Luton Town were deducted an insurmountable thirty points.

The club would now struggle to attract players to a team that was destined to spend the season fighting for their lives. The receivers came in and said to the playing staff, 'It is up to you whether you carry on playing. You can forfeit the fixtures if you want to. You can leave on free transfers if you wish.' The players held a meeting and every single player was adamant that they were willing to battle on.

The team got off to a poor start and after only four games, manger Kevin Bond, assistant Rob Newman, and Eddie Howe, who had a role with the academy, were all relieved of their duties by new Chief Executive Officer Alistair Saverimutto. The next day, 2 September 2008, Jimmy Quinn was unveiled as the new manager, with Jason Tindall as his assistant.

The side continued to struggle to make up the lost ground but were getting further adrift at the bottom.

By Christmas, the Cherries had made up the seventeen points, which in effect gave them a grand total of zero points; then two defeats immediately after Christmas made the situation even more perilous.

To rub salt into the wounds, there followed a humiliating defeat to non-League Blyth Spartans in the FA Cup, which proved to be a real low point and resulted in Quinn being shown the door. Eddie Howe was then put in temporary charge, making him by far the youngest manager in the league at the age of thirty one, with Jason Tindall as his assistant. The situation seemed absolutely calamitous and it was generally believed that only a miracle could get the club out of the mire.

At this time also, Paul Baker announced that he could no longer fund the club. Both the Football League status and the very existence of the club looked bleak.

Eddie Howe set to work as bailiffs took anything that wasn't nailed down, including the entire stock of the club shop.

One of the first things Eddie did was to phone his old mate Steve Fletcher. Having played with the big man, he appreciated that he could have an inspirational role to play.

At the time he was contracted to play for Crawley Town, but was rarely getting a game. Eddie pestered Fletch daily, and in the end the Crawley manager, Steve Evans, let him go as he realised how much playing for Bournemouth meant to him. He re-signed for Bournemouth on 23 January 2009, at the age of thirty-six, and he stated that 'he would play every game as if it were his last'.

The arrival of Big Fletch did indeed give the club a lift, especially when he started banging in the goals that were keeping Bournemouth's hopes alive.

The situation off the field continued to go from bad to worse, as the club was put under a transfer embargo, and at the same time Baker was actively trying to sell the club.

During this period, the players had to wait for the gate receipts of a home game before they could be paid; but despite this, performances on the pitch continued to improve, as Howe, Tindall and Fletcher galvanised the threadbare squad and lifted moral.

After winning the penultimate game and the game before that, Bournemouth had miraculously got themselves into a position where they had a chance. They had to win their last game against Grimsby on 25 April 2009 to retain Football League status.

Grimsby took the lead just before half-time, But Warren Feaney equalised early in the second half. The stage was set for the big man himself (Fletch) to score the winner in the eightieth minute, his 100th league goal for the club, and what a time to score it. Cue general delirium around Dean Court.

Shortly afterwards, to add to the sense of well-being, Howe and Tindall pledged their futures to the club.

## Eddie Howe

Eddie Howe was born on 29 November 1977 in Amersham, Buckinghamshire. At the age of ten his family moved to Verwood, Dorset, just outside Bournemouth, where he attended Queen Elizabeth's School, Wimborne, and played for local youth teams Rosgarth and Parley Sports, before being spotted by Bournemouth Academy.

He became a Bournemouth trainee in 1994, making his first-team debut in October 1996, before going on to establish himself as an important player in Bournemouth's defence.

International recognition came in 1998, when he was selected for England U21 team in the Toulon Tournament.

In March 2002, he was transferred to Portsmouth, where he became Harry Redknapp's first signing as Pompey manager. Unfortunately he damaged his knee shortly after signing and endured a frustrating period of injury.

He was at Portsmouth until 2004, when he went to Swindon Town on loan, and then Bournemouth on loan, before re-signing permanently for his home town club, where he remained until the end of his playing career in 2007.

He made most of his 300 league appearances for Bournemouth, and was known as 'Steady Eddie', an unflappable and highly competent defender.

When his playing career finished, he had a role with the Academy, before being thrust into the lion's den, as caretaker manager in 2009, at the tender age of thirty one.

He was by far the youngest manager in the Football League, and the club were in dire straits, both financially and on the pitch. He later admitted that 'when he was handed the job, he didn't feel ready and felt the club were taking a massive risk'.

## Jason Tindall

Jason Tindall joined Bournemouth as a player from Charlton in 1998. He then moved to non-League Weymouth in 2006 after a series of knee injuries curtailed his playing career at Bournemouth.

He was appointed as Bournemouth's assistant manager to Jimmy Quinn in 2008, but then Quinn was sacked in 2009, and Eddie Howe was promoted to caretaker manager.

This was the time of the transfer embargo, and a threadbare squad, so one of Eddie Howe's first actions was to re-register his old teammate as a player. He did manage to make a few appearances, when injuries to other players required him to do so, despite his dodgy knees.

## Steve Fletcher

Steve Fletcher was originally from Hartlepool, but joined the Cherries aged nineteen. He had played a blinder for Hartlepool against Bournemouth, prompting then manager Tony Pulis to sign him in 1992. He soon became a truly inspirational 'up and at em figure'; a traditional old-style, English centre forward. He was player of the season during the first great escape of 1994/95, and also scored the goal in the play-off final which saw Bournemouth promoted in 2003.

By 2005, he had broken the appearance record at the club, but was released in 2007, before being recalled by Eddie Howe in 2009. He repaid Eddie Howe's faith in spades when he played a massive part in the 'Greatest of Great Escapes', and scored the goal that ensured the Cherries stayed in the Football League.

He later became assistant manager to Lee Bradbury, before achieving the honour of having a stand named after him. He now works for the club as a scout.

## From Rags to Riches

Adam Murry then came in and set up the Murry Group in June 2009, which took control of the club as the financial worries increased. This was a five man consortium which included Adam Murry, Jeff Mostyn, Steve Sly, Neil Blake and Eddie Mitchell; a local businessman, who had previously been chairman of Dorchester Town.

The 2009/10 season was Eddie Howe's first full season in charge. The club were still facing a transfer embargo, and had only just managed to avoid going into oblivion the previous season.

They had the smallest squad in the league, and the situation was compounded by players suffering long-term injuries.

At one point, Jayden Stockley, a sixteen-year-old schoolboy, was called into the squad against Burton Albion on 26 September 2009, enabling Cherries to name the minimum three required on the bench that the Football League stipulated. Shortly afterwards on 6 October 2009, Cherries fielded three sixteen-year-old schoolboys away to Northampton and Eddie Howe had to write to their headmasters to take them out of school (at least back in those days local youngsters could get a chance).

Jason Tindall also managed to make a handful of appearances despite the poor state of his knees.

Financial problems continued and a dispute with a creditor resulted in legal action against them.

Unsurprisingly, they were written off as no-hopers, but amazingly they soon found themselves in the top three, and as the team continued to accumulate points, promotion began to look like a realistic possibility.

The situation started to look rosier off the field as well; the club managed to clear its debts, and the transfer embargo was lifted, albeit after the transfer window had closed.

The season eventually hinged on a simple equation: a win against Burton Albion would secure promotion to League One (third tier).

It was fitting that Brett Pitman, who had been firing on all cylinders throughout the season, should score the first goal. Alan Connell then scored the second with his first touch of the ball in the last minute, after coming on as a sub, to send AFC Bournemouth into League One.

Eddie Howe had rescued Bournemouth from dropping out of the Football League in his first season as manager, and had then won an amazing promotion against all the odds in the next.

## 2010/11

Bournemouth continued to do well at the start of the 2010/11 season, but Eddie Howe was now hot property, and there was disappointment when Eddie and his assistant Jason Tindall moved to Burnley, to take over a team that had just been relegated from the Premier League.

Former Bournemouth player Lee Bradbury became the new manager, with club stalwart Steve Fletcher as his assistant in January 2011.

The team continued to play scintillating football, and Cherries very nearly made it back-to-back promotions, but were defeated in the semi-final of the play-offs by Huddersfield in a heartbreaking penalty shoot-out.

## 2011/12

Lee Bradbury was dismissed and Paul Groves took over on 26 March 2012. The season was pretty nondescript and Cherries finished eleventh in League One (third tier).

Around this time, wealthy Russian businessman Maxim Denim was persuaded to become co-owner by former chairman Eddie Mitchell, after Mitchell's building firm had been contracted to build the Russian's luxury home in Sandbanks. He teamed up with existing chairman Jeff Mostyn.

## 2012/13

Paul Groves was dismissed early in the season on 3 October 2012 and everyone at Bournemouth was delighted when Eddie Howe and Jason Tindall returned from Burnley.

The duo had given their all at Burnley and had put together a good side, featuring many ex- Bournemouth players; but for Howe it was an easy decision to return to AFC Bournemouth when they came knocking, as both his and his wife's roots were in the south coast/Bournemouth area.

Eddie waved his magic wand again, and on 20 April 2013 Bournemouth beat Carlisle 3-1 and secured promotion to the Championship (second tier). It was only the second time in their history – the previous time was under Harry Redknapp, who Howe had cited as one of his influences from when he played for him at Portsmouth.

## 2013/14

The team finished tenth in the Championship, just missing out on a play-off spot.

## 2014/15

The following season, a thirteen-game unbeaten run proved to be the decisive factor in Bournemouth finishing as champions of the Championship. A 3-0 victory over Bolton Wanderers provided confirmation that Bournemouth would be playing in the top flight of English football for the first time in their history.

There had been almost two decades of wondering whether the club would live to fight another season, amidst a backdrop of financial disaster. They had so nearly been forced out of existence, but had gone from the brink of oblivion to the elite of the Premier League.

Who would have dared to dream back in the dark days of 2009, after reaching so many low points – entering administration, the despair of getting relegated at Carlisle, the seemingly insurmountable seventeen-point deduction, and then FA Cup humiliation at Blyth – that six years later Bournemouth would be in the Premiership. They are the smallest club to have ever reached that nirvana, with a ground capacity of less than 12,000.

To cap it all, Eddie had done it in a way most mangers and pundits deemed impossible, with an English management team and an almost entirely English squad. What was also unique was that through the dark times it was the supporters who had kept the club going by forming a Community Club.

Eight of the players responsible for the ascent to the summit had made the step up from League One (third tier) football with the club. There was also one survivor, Brett Pitman, from the team that narrowly avoided relegation from the Football League.

An open-top bus parade took place through the town and along the beach promenade from Boscombe to Bournemouth Pier.

Howe's success saw him secure the inaugural Football League Manager of the Decade in 2015, and the departure of Arsene Wenger from Arsenal in 2018 meant that Eddie Howe was now the longest-serving manager in the Premier League.

Bournemouth had completed the ultimate fairy-tale rags to riches story that even Hans Christian Andersen would have considered too far-fetched. The journey had been a rollercoaster ride – a roller coaster that if real would have been banned by health and

safety for having too many twists and turns! Then on 5 March 2019, Howe was awarded the Freedom of the Borough of Bournemouth.

'Football, as they say, is a 'funny old game'.

## Postscript

Sadly, an unfortunate postscript to the story is that Bournemouth's great adventure seems to have come to an end, for the time being, as in the Covid-19 affected season of 2019/20 their luck finally ran out after only two wins in thirteen games had put them in a perilous position, and they were relegated to the Championship (second tier) after five years among the privileged few of the Premiership.

South coast rivals Southampton applied the *coup de grace* in the penultimate game, during which Bournemouth required at least a point to have a fighting chance on the last day of the season. They thought they had salvaged a point in the dying minutes when local lad Sam Surridge appeared to have equalised to make the score 1-1, only for the goal to be erased when VAR (Video Assistant Referee) showed it was offside. Southampton then went up the other end almost immediately to make the score 0-2.

Bournemouth then faced a situation where they only had the slenderest of chances on the last day of the season; whereby if Watford or Aston Villa gained even a single point, then one of those, depending on goal difference, would stay up at the expense of Bournemouth, regardless of what Bournemouth did themselves. However if, Bournemouth won and both Watford and Aston Villa lost, Bournemouth would stay up.

Alas it wasn't to be. Bournemouth did win their game 1-3 against Everton, and Watford lost 3-2 against Arsenal; but the point Aston Villa managed against West Ham in a 1-1 draw was enough to seal Bournemouth's fate.

Eddie Howe then left by mutual consent. He had given his body and soul to the club for twenty-five years, but felt he had come to the end of the road and that it was time to part ways. The club chief executive, Neil Blake, said, 'Eddie Howe is synonymous with this football club and that will never change.' Eddie Howe in return said it was the hardest decision he ever had to make, 'especially when it was a case of leaving personal friends'.

Fittingly, Jason Tindall has now been promoted to the managerial hot seat, and as AFC Bournemouth owner Maxim Denin said, 'Jason has played a huge role in this club's success over the last decade and truly deserves to step up and become the new manager.'

# 5. Music, Literature and Entertainment

## Music
### Bournemouth Symphony Orchestra

In 1876, a group of ex-Italian Army musicians known as the Italian Band performed for Bournemouth residents and visitors on a regular basis. They were led by Signor Bertini and became so popular that the town authorities allowed them to form the first Corporation Military Band.

In 1893, Bournemouth Town Council went one step further and invited Dan Godfrey, who was one of Britain's premier musicians and bandmasters, to lead the first municipal orchestra in the country.

He was not interested, but luckily his son, also named Dan Godfrey, read his father's mail. He was twenty-four and had just returned from South Africa as a musical director of a touring company. He saw this as a great opportunity, so applied for the job himself. His application was successful and his appointment heralded a great success story that eventually led to the Bournemouth Symphony Orchestra becoming world famous.

Initially the orchestra played in the Winter Gardens, which was an exhibition centre along the lines of London's Crystal Palace. It was predominantly constructed of glass, and was not too popular with the musicians. It was stiflingly hot, as well as being noisy when it rained; but despite the difficult conditions, the orchestra was beginning to attract many plaudits, and the likes of Edward Elgar, Hubert Parry and Gustav Holst came to conduct.

The Pavilion.

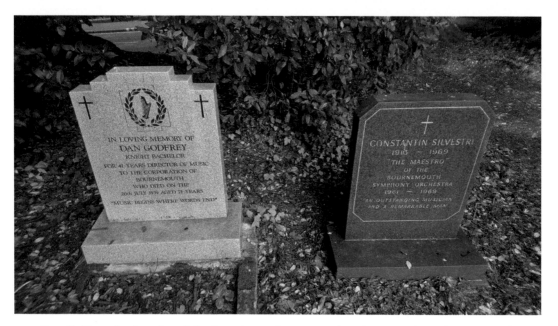

Dan Godfrey, the founder of the Bournemouth Municipal Orchestra, is buried at St Peter's Churchyard, Bournemouth, next to Constantin Silvestri, the Romanian-born conductor who also played a pivotal role in raising the prestige of the orchestra.

By 1921, the Winter Gardens had shut, and the orchestra, who were now in dire financial straits, were reduced to playing on the pier. However in 1929, the Pavilion was opened, at the site of the Old Belle Vue Hotel, and the orchestra had a new residence.

After the Second World War, the orchestra found itself in a sorry state again, but in 1947, the orchestra moved to a refurbished building originally built as a bowling alley. The location was familiar, as it was at the site of their old home, the Winter Gardens, where the acoustics were now fantastic.

The orchestra continued to perform outstandingly well to a backdrop of public indifference, and by 2002, the Winter Gardens was condemned to demolition and the orchestra was disbanded.

Now, when it was too late, the public got behind the orchestra, and there were numerous protests and petitions, but Bournemouth Borough Council still demolished the Winter Gardens in 2003, and the site is now a car park.

However the Bournemouth Symphony Orchestra has now found a new home outside Bournemouth, at the Lighthouse – Poole's Centre for the Arts – and continues to flourish as a world-renowned orchestra.

## Ray Dorset

Ray Dorset was the lead singer and the driving force behind the legendry Mungo Jerry, who are best known for the song *In the Summer Time*, which was a massive hit in 1970 and contained one of the most politically incorrect lines of all time: 'Have a drink. Have a drive. Go out and see what you can find.'

Despite the appropriate surname for where he now lives, Ray was actually born in Ashford, Middlesex, on 21 March 1946, but has lived a large part of his life in Westbourne, Bournemouth.

## Alex James
Alex James, Blur's bass player, was born and brought up in Boscombe and attended Bournemouth School for Boys, which is where he first started playing in bands.

After his success with Blur, he moved to a 200-acre farm in Oxfordshire, where he is a cheesemaker of some repute. He also hosts a music event called 'The Big Festival at the Farm'.

## Hubert Parry
Hubert Parry (1848–1918) is best known for writing the choral song *Jerusalem*.

He was born in Bournemouth, but unfortunately his mother died of consumption twelve days after his birth. She is buried at St Peter's Church, where Hubert was baptised two days later.

He was given the prestigious position as head of the Royal College of Music in 1895, and remained in the post for the rest of his life, occasionally returning to his home town to conduct the Bournemouth Symphony Orchestra.

## Bournemouth's Literary Connections
### Bournemouth Echo
Bill Bryson, the American travel author, worked as a journalist on the *Bournemouth Evening Echo* at one time, as did TV presenter Anne Diamond.

## Rupert Brooke
The famous First World War poet Rupert Brooke first came to Bournemouth aged nine to visit his grandfather and two maiden aunts.

His grandfather had moved to Bournemouth in 1895 after retiring as the rector of Bath Abbey. His two unmarried daughters, Lizzie and Fanny, joined him shortly afterwards.

The house in Dean Park Road was called Grantchester Dene, which was appropriate, as Rupert later moved to Grantchester, Cambridgeshire.

It was in Bournemouth though that Rupert first enjoyed listening to his relations reciting poetry, and where he discovered a love of the form.

During the First World War, he served in the Royal Navy, but undertook his basic training at Blandford Camp, Dorset, which enabled him to continue to visit Bournemouth regularly.

He wrote, 'but now I shall expire vulgarly at Bournemouth and they shall bury me at the shore near the bandstand. I have been in this quiet place of invalids and gentlemanly sunsets for about a hundred years since yesterday week'.

His patriotic poems at the outset of the First World War made him a national hero before the horrific reality of that conflict was fully appreciated by the public. His most famous offering was *The Soldier*, which includes the iconic line 'if I should die, think only this of me: That there is some corner of a foreign field. That is forever England'.

In 1915, the navy sent him to the Mediterranean, where he was bitten by an infected mosquito from which he contracted the sepsis that killed him.

### Charles Darwin

In November 1859, Charles Darwin published *On the Origin of Species*, which was somewhat controversial and made him famous.

In the book, Darwin espoused the 'theory of evolution by natural selection', which insisted that all species evolved over time from common ancestors, which was at odds with the accepted theory of the time: that God created everything.

Three years after the publication of that book, his son developed scarlet fever, so Darwin rented Cliff Cottage in Bournemouth for a month to aid his recovery. The cottage was where the Bournemouth International Centre (BIC) now stands.

On the journey to Bournemouth his wife also caught the disease, necessitating Darwin having to rent a separate house for his wife and son, 'one for the sick and one for the well ones'.

Whilst his family recovered, Darwin wrote, 'I do nothing. This is a nice but barren country and I can find nothing to look at. Even the brooks and ponds produce nothing. The country is like Patagonia.'

### John Galsworthy

The novelist and dramatist, most famous for *The Forsyte Saga*, first came to Bournemouth in 1876, aged nine, to attend Saugeen Preparatory School for boys in Derby Road, which has long since disappeared. Whilst there, he was also a chorister at nearby St Swithun's Church.

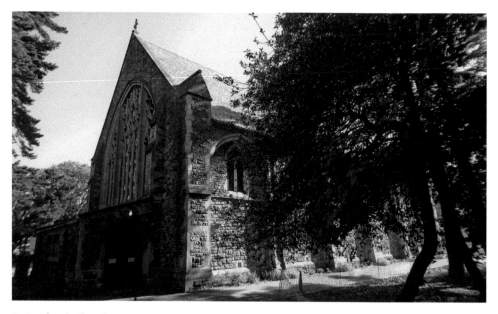

St Swithun's Church.

He is said to have based the character Thomas Gradman from *To Let,* the final part of the *Forsyte Saga*, on his father's clerk, Joseph Ramsden, who used to take him to school from his home in Surrey.

Galsworthy was awarded the Order of Merit in 1929 and received the Nobel Prize for Literature in 1932.

## Thomas Hardy

The author who is synonymous with Dorset referred to Bournemouth as Sandbourne and used the location in two of his novels: *Hand of Ethelberta* and *Tess of the D'Urbervilles.*

In the *Hand of Ethelberta* (1876), Sandbourne is where Ethelberta's family have their last home, called Firtop Villa. He mentions the old wooden pier which was replaced by an iron pier in 1880.

In *Tess of the D'Urbervilles*, Tess murders her seducer, Alec, in a boarding house in Sandbourne, called *The Herons*, before running away with her true love and estranged husband, Angel Clare. He also refers to Sandbourne in this novel as 'the city of detatched mansions'.

Hardy liked Bournemouth and described it thus:

The fashionable watering place, with its eastern and its western stations, its piers, its groves of pines, its promenades and its covered gardens, was like a fairy place suddenly created by the stroke of a wand, and allowed to get a little dusty. An outlying eastern tract of the enormous Egdon waste was close at hand, yet on the very verge of that tawny piece of antiquity such a glittering novelty as this pleasure city had chosen to spring up.

On another occasion, Hardy described Bournemouth as 'a Mediterranean lounging place on the English Channel'.

## John Keble

John Keble (1792–1866) was a churchman and poet. He was the author of a book of poems intended for use on Sundays and feast days, called *The Christian Year*. The book was an aid to meditation and devotion, to be used in conjunction with the prayer book. It became the biggest-selling book of verse in the nineteenth century.

He was a leading light in the Oxford movement, which was a movement associated with Oxford University. They favoured a higher Christian Church and the reinstatement of other Christian traditions.

After completing thirty years as vicar of Hursley, near Winchester, John Keble and his wife were ailing in health so retired to Bournemouth in 1865, to benefit from the therapeutic benefits of the town. They settled at a boarding house in Exeter Lane called Brookside.

Unfortunately they both died the following year within six weeks of each other.

A stained-glass window was installed in his honour in the south transept of St Peter's Church, and then in 1906 the whole transept was dedicated to him.

Keble College Oxford was also founded in his memory.

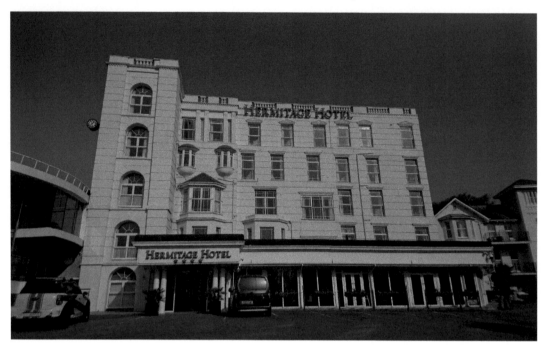

Brookside, the boarding house that John Keble and his wife stayed in, is now the Hermitage Hotel.

### D. H. Lawrence

In 1912, D. H. Lawrence came to Bournemouth on his doctor's advice. He was suffering from a mental breakdown after the death of his mother and the break-up of his relationship with his childhood sweetheart.

Before he arrived he wrote to a friend. 'I am actually going to Bournemouth, to Compton House, St Peter's Road, a boarding house, God help us.'

A week later he wrote to the same friend. 'I don't like it very much. One is always churlish after an illness. When I am better tempered I shall like the old maids and the philistine men and the very proper and propitious maidens right enough.'

Later he wrote to Louie Burrows, to whom he was engaged for fifteen months before he eloped with Frieda Weekley. 'The town is very pretty. When you look at it. Its quite dark green with trees. There is a great bay and long smashing waves. I don't flirt with the girls – there are some very pretty ones – only with the old maids and I do about two hours work a day.'

### Shelley Family

The Shelley family are part of the heritage of Bournemouth, although strangely the only family members that actually lived in Bournemouth were Percy Florence Shelley and his wife, Jane.

However, Mary Shelley, the *Frankenstein* creator, was so enamoured with Bournemouth that she wanted to be buried in the town, and arranged for the rest of the family to be buried in the same St Peter's Churchyard as well.

*Above*: This popular town centre Wetherspoon's pub was created in acknowledgement of Mary Shelley. Wetherspoon's also recognised the contribution made to the area by her son, with the 'Percy Florence Shelley' in Boscombe, which closed in 2017.

*Right*: The Mary Shelley pub sign.

### Percy Bysshe Shelley

Percy Bysshe Shelley was one of the main English romantic poets, and formed part of a group of friends that were all innovative poets and writers. They included Lord Byron, John Keates, Leigh Hunt, Thomas Love Peacock and Percy's second wife, Mary Shelley.

Percy Shelley's poetry is widely appreciated today, but during his lifetime publishers were wary of the seditious and blasphemous nature of his work. It is also believed that his theories were a major influence on Karl Marx. However, his poetic brilliance and influence are recognised by a mural in Poets' Corner, Westminster Abbey.

### Mary Shelley

Mary Shelley was the second wife of the poet Percy Bysshe Shelley and she was the daughter of the political and social radical William Godwin and the feminist Mary Wollstonecraft.

Mary eloped with Percy when she was seventeen and they spent their entire marriage abroad. She returned to England after her husband's death and wrote *Frankenstein* in 1818.

### Percy Florence Shelley

Percy Florence Shelley was the son of poet Percy Bysshe Shelley and Mary Shelley. In 1844, he inherited his grandfather's title and property, becoming Sir Percy Shelley, and shortly afterwards married Jane St John.

In 1850 he purchased an existing farmhouse, which was built in 1801 to create Boscombe Manor, a house on the clifftops, for himself and his wife, Jane. The intention was also for his mother, Mary, to live there in the hope that the sea air may aid her ailing health.

In the event his mother died in 1851, aged fifty-three, before the move to Boscombe was completed. She is buried in St Peter's Churchyard alongside the heart of her husband, Percy Bysshe Shelley.

However, Percy Florence Shelley and his wife, Jane, lived at Boscombe Manor happily. Percy immersed himself in painting and sailing, while Jane collated manuscripts and memorabilia of Percy Bysshe Shelley and his wife, Mary.

One thing they enjoyed together was amateur dramatics, which they staged in their own theatre attached to Boscombe Manor.

Boscombe Manor became renowned as a centre for culture, literature and drama, hosting such luminaries as Sir Henry Irving, Sir Beerbohm Tree and Robert Louis Stevenson, as well as old friends such as Trelawney and Leigh Hunt.

The building was purchased by Bournemouth Corporation in 1937 and renamed Shelley Manor. It was used as an art college, but then fell into disuse before being restored by the Charles Higgins Trust to become Shelley Manor NHS Medical Centre, which incorporates a GP surgery and a pharmacy, as well as dentistry and physiotherapy.

The Shelley Theatre is still in operation next door and is used for plays, cinema, live music, lectures, dance shows, workshops and more; but unfortunately, the Shelley Rooms Museum closed in around 2000.

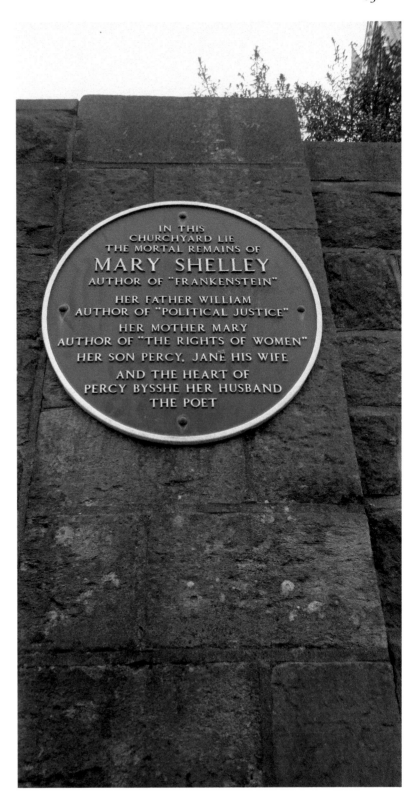

IN THIS
CHURCHYARD LIE
THE MORTAL REMAINS OF
MARY SHELLEY
AUTHOR OF "FRANKENSTEIN"

HER FATHER WILLIAM
AUTHOR OF "POLITICAL JUSTICE"

HER MOTHER MARY
AUTHOR OF "THE RIGHTS OF WOMEN"

HER SON PERCY, JANE HIS WIFE

AND THE HEART OF
PERCY BYSSHE HER HUSBAND
THE POET

A plaque at
St Peter's Church.

The Shelley Theatre.

Shelley Manor, which is now an NHS GP surgery and medical centre.

A plaque at Shelley Manor.

The Shelley Family Vault in St Peter's Churchyard

The Shelley family vault is in St Peter's Churchyard.

Mary Shelley expressed a wish that she should be buried in Bournemouth, and also that she should be near her parents, so accordingly both parents were brought from their graves at Old St Pancras Church, London, by Mary's son, Percy Florence, to join their daughter in 1851.

Percy Bysshe Shelley drowned in Italy in 1822 whilst on a boating excursion. At his funeral, a friend, Trelawney, grabbed Shelley's heart from the burning funeral pyre and gave it to Mary.

The heart is buried alongside Mary, along with their son Percy Florence Shelley and his wife Lady Jane Shelley.

There is also a monument to Percy Bysshe Shelley and his wife, Mary Shelley, at the west end of Christchurch Priory on the north wall, which is inscribed with the words from *Adonais,* which Shelley wrote on the death of Keates.

St Peter's Church.

### Robert Louis Stevenson

Robert Louis Stevenson lived at a house called Skerryvore in Westbourne from April 1884 until August 1887, with his newlywed American wife and stepson.

He came to Bournemouth to enjoy the health benefits. He was certainly productive during his stay in the town, writing both *Kidnapped* and *The Strange Case of Dr Jekyll and Mr Hyde*.

It was claimed that a prescription of hemp medicine for curing consumption was responsible for Stevenson having the lucid dream that provided the inspiration for the story. He described his creative energy at that time as being 'within him like a weevil in a biscuit'.

The house, which was named after the Skerryvore Lighthouse built by the Stevenson family firm on the Argyle coast, was destroyed by a German bomb on 16 November 1940 (*see* Wartime and Aeronautical Events). The memorial garden that now exists at the site includes a model of the lighthouse.

### J. R. R. Tolkien

The author of *The Hobbit* and *The Lord of the Rings* was, along with his wife, a frequent holiday guest at Bournemouth's Miramar Hotel. They always took the same room, plus an additional room to write in. However, in the late 1960s, the couple retired to nearby Poole, so then had no need to stay at the Miramar.

### Paul Verlaine

In 1876, the celebrated French poet Paul Verlaine arrived in Bournemouth, having just served a prison term for wounding his former friend, Rimbaud.

The remains of Robert Louis Stevenson's House, Skerryvore.

 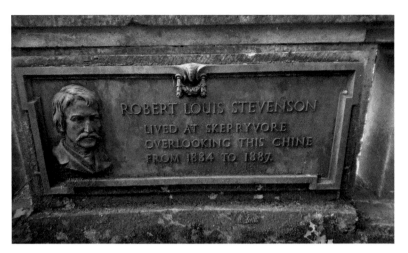

*Above left*: A model of the Skerryvore Lighthouse at the Robert Louis Stevenson Memorial Garden.

*Above right*: A plaque on a bridge at the top of Alum Chine.

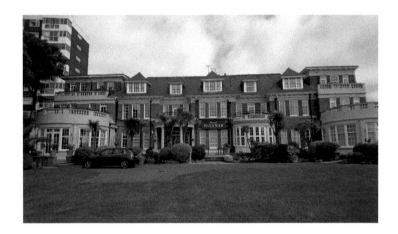

The Miramar Hotel.

The Sacred Heart Church, where Paul Verlaine spent a lot of his time whilst in Bournemouth.

He liked Bournemouth as he was able to live quietly and anonymously whilst teaching French at St Aloysius private school. In fact, when he wasn't teaching, he spent the majority of his time at the Sacred Heart Church in Albert Road, Bournemouth.

Verlaine wrote two poems about the town. One is simply called *Bournemouth* and describes the serenity and beauty of the town. The other is called *La Mer de Bournemouth*.

However a return to France in September 1877 saw him return to his previous debauched lifestyle, before he died in Paris in 1896.

## Films
### Stewart Granger
East Cliff Cottage Hotel, Grove Road, Bournemouth, built in 1895, was home to the British actor Stewart Granger. His name was actually James Stewart, but he changed his name in order to avoid confusion with the American actor of the same name.

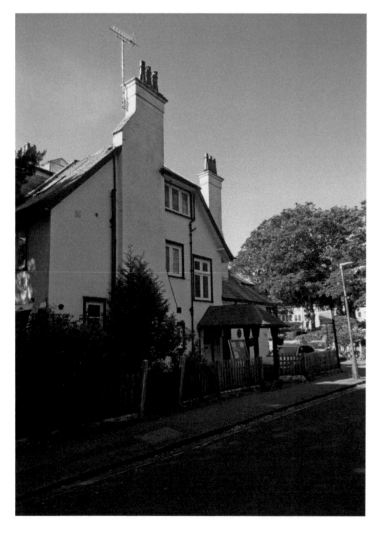

The East Cliff Cottage Hotel was home to the British actor Stewart Granger.

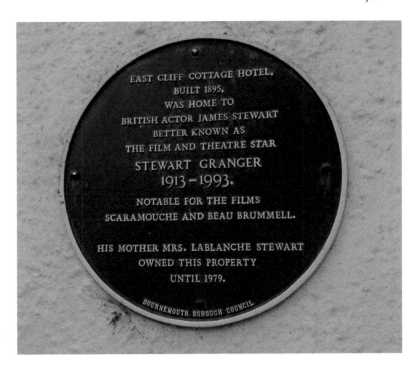

A plaque on the East Cliff Cottage Hotel.

He was mainly associated with heroic and romantic leading roles, and was popular from the 1940s to the 1960s.

He made his first theatre appearance in 1935 in *The Cardinal*, at the Little Theatre, Hull. He then joined the Birmingham Repertory Company between 1936 and 1937, before making his debut in London's West End in *The Sun Never Sets* in 1938.

At the beginning of the Second World War he joined the Gordon Highlanders and then became a Second Lieutenant in the Black Watch. However he was invalided out of the army in 1942 due to stomach ulcers.

In 1943, he appeared in *The Man in Grey* (1943) for Gainsborough Pictures, which proved to be his major breakthrough and led to many more roles, including *Scaramouche* and *Beau Brummell*, which are generally considered to be his best films.

As far as his private life was concerned, he was married and divorced three times, most famously from 1950 to 1960 to the famous British actress Jean Simmons.

After he left Bournemouth, his mother, Mrs Lablanche Stewart, continued to own the house until 1979.

## Theatre
### *Lillie Langtry*
The Jersey-born socialite, actress and producer, whose full name was Emile Charlotte Langtry (née Le Breton), was most famous for being the mistress of the Prince of Wales, later to became King Edward VII. She lived in Bournemouth for seven years, at the Red House in Derby Road, which was the love nest the Prince had built for her. The house is now the Langtry Manor Hotel and Restaurant.

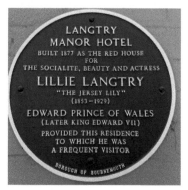

*Above left*: The Langtry Manor Hotel.

*Above right*: A plaque at the Langtry Manor Hotel.

## Oscar Wilde

In 1883, the highly entertaining performer Oscar Wilde was much in demand. He had just completed a lecture tour in America, and was booked to appear at the Theatre Royal, Albert Road, Bournemouth, to deliver a talk on *The House Beautiful.*

It seems that his hectic schedule had left him a little out of sorts, as he mistakenly arrived in the evening, having missed his afternoon show.

He wrote to the theatre manager, apologising, and said 'if I am ever forgiven in Bournemouth, I hope to be asked back'. He was invited back the following weekend, and performed to a highly appreciative sell-out audience.

He was a regular visitor to Bournemouth and a regular visitor to the Royal Bath Hotel; so much so that they named Oscars restaurant after him, and also appropriately, a late night bar called Wilde's Whisky Snug.

## Television

### Max Bygraves

Max Bygraves, the comedian, singer and game show host, spent his retirement at Sandbourne Road, Westbourne, before emigrating to Australia in 2008.

On 9 August 1974, he was flying a kite with his grandson, and then had to be rescued by police and firefighters when he became stuck on the cliffs at Westbourne whilst trying to retrieve it.

### Fanny Craddock

The acerbic TV chef Fanny Craddock (1909–93) attended Bournemouth High School (now Talbot Heath) from the age of fifteen.

### Tony Hancock

The Hancock family moved to Bournemouth in 1927, when Tony was just three. His father worked first in a laundry and then in a pub, before spotting an opportunity for the family to take over a hotel in 1933.

Initially they were at the Railway Hotel in Holdenhurst Road, but after his father's death the family, including stepfather Robert Gordon Walker, moved to Durlston Court Hotel in Gervis Road, which is now called Hotel Celebrity.

Tony attended Durlston Court Preparatory School, near Swanage, and this was the inspiration for the name of the hotel.

Tony's first engagement was at the Sacred Heart Church at Richmond Hill, and his first professional performance was at the Avon Social Club, Avon Road, in 1940. His persona and comedy routines, which saw him revered as one of the funniest men ever to have graced British TV comedy, were said to have been influenced by his years growing up in the town.

### Benny Hill
At the beginning of the Second World War, Benny Hill was evacuated from Southampton to Bournemouth, along with his entire school. He was billeted with a family in Winton and attended Bournemouth Boys' School.

Taunton's School from Southampton attended lessons in the morning, and then made way for the actual Bournemouth Boys' School in the afternoon.

### One Foot in the Grave
The TV series *One Foot in the Grave* was predominantly filmed in Bournemouth.

The house scenes were initially filmed at a house near Pokesdown, but when this changed hands, the new owners demanded considerably more money, and the production

The Celebrity Hotel.

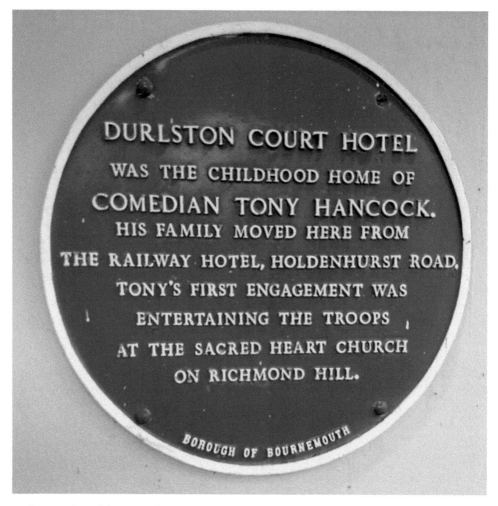

A plaque at the Celebrity Hotel.

team had to find an alternative. Accordingly, the first episode of the following series involved the Meldrews' house being destroyed by fire, which was filmed on an area of waste ground near Northcote Road.

Filming of the house scenes then moved to Walkford near New Milton in Hampshire. However, most of the outside locations were still filmed in and around Bournemouth including Richmond Hill, Undercliff Drive, Boscombe Pier, Bournemouth Town Hall, Lansdowne College and the former Royal Victoria Hospital, Boscombe.

# 6. Miscellaneous

## Alum

Alum Chine derives its name from a period in the late sixteenth century when alum and copperas were mined in the vicinity.

Alum was used by tanners to aid the adhesion of dye to a material. Whilst copperas was also used for the same purpose, it was mainly used with black dye.

The alum and copperas mining at Alum Chine proved unprofitable, and by the mid-seventeenth century mining had ceased.

## Bath Chair

Bournemouth has had a reputation as the ideal resort for the elderly and infirm, and the image of an elderly person being wheeled along the promenade in a bath chair is still many people's impression of the town.

However, there is now only one remaining bath chair in Bournemouth, which is held in the Russell Cotes Museum.

## Anthony Blunt

Soviet spy Anthony Blunt (1907–83) was born in Bournemouth. His father was the vicar of Holy Trinity Church, Old Christchurch Road, which has long since gone.

Blunt was in the Intelligence Corps of the British Army, and was evacuated from Dunkirk in 1940. He then rose to the rank of major, before being recruited by MI5 and also by the KGB to whom he passed on classified information.

He was discovered and stripped of his knighthood for treason, along with his fellow Cambridge-educated Soviet spies Guy Burgess, Kim Philby and Donald Maclean in 1979.

Alum Chine.

## Boscombe Whale

On January 5 1897, an enormous blue whale was struck by a merchant ship and subsequently washed up on the beach at Boscombe.

The creature was 70 feet long and weighed 40 tons. It was soon drawing large and inquisitive crowds, and local children were not slow to realise the potential of the rotting carcass as a toboggan run.

The coastguard sold the beast at auction to Dr Spencer Simpson, who intended to use the skeleton as a lecture aid. Meanwhile the council sent a sanitary inspector to remove the public health hazard, which resulted in Dr Simpson being arrested for assaulting the official.

Eventually, Dr Simpson managed to rid himself of the blubber surrounding the carcass, by dumping most of it off Brownsea Island, and then auctioning the rest outside the Kings Arms (now the Stable) on Poole Quay. The auctioneer had his work cut out, as there were very few people at the auction, and those that were there were mainly there through curiosity. However, eventually the lot was sold for just five shillings, which didn't give the doctor a very good return considering it had cost him £135.00 to transport the blubber to Poole.

The remaining carcass was displayed by Dr Simpson at Boscombe Pier for his educational purposes. However, the same urchins who enjoyed sliding down the blubber also took great delight in sliding down the bones, and it only survived a few years before being removed in 1904.

## Chang Woo Gow

Chang Woo Gow was one of Bournemouth's most colourful characters. He was 8 feet tall and weighed 20 stone, earning him the moniker of 'Chang the Chinese Giant'.

He was born in Foochow, China, but toured the world as a 'curiosity' for twenty-five years, before marrying an Australian lady and settling in Bournemouth, in a bid to aid his Tuberculosis. They ran a Chinese tea shop and lived at a house in Southcote Road, called 'Moyuen', which is now the Ashleigh Hotel.

The Ashleigh Hotel which was formerly a Chinese tea shop managed by Chang Woo Gow and his wife.

A plaque at the Ashleigh Hotel.

## Chines

The chines are a distinctive feature of the Bournemouth and Poole seafront. They are a phenomenon of coastal southern England, particularly Dorset, East Devon, Hampshire and the Isle of Wight. The name is derived from the Anglo-Saxon *cine*, meaning chink or fissure. They are steep-sided, narrow ravines which were initially eroded by streams leading to the sea.

*The Chines in Order Moving from Bournemouth Pier Westwards*
Water Chine
Water Chine is a small inlet immediately west of the pier.

Little Durley Chine
Little Durley Chine can be ascended by means of West Cliff Zig Zag (see Joseph's Steps).

Durley Chine
Durley Chine is the first of the larger inlets.

Middle Chine
*Alum Chine*
Alum Chine is nearly three quarters of a mile in length and incorporates a public tropical garden, which originated in the 1920s and provides a peaceful seaside retreat.

*Chines Moving East from the Pier Towards Boscombe*
Honeycombe Chine
Boscombe Chine
Bournemouth town centre itself is built in the former Bourne Chine, the pleasure gardens being the original valley floor.

*Above left*: Middle Chine.

*Above right*: The tropical Gardens at Alum Chine.

Boscombe Chine.

Boscombe Chine Gardens.

## Cinema

Britain's smallest cinema is tucked away in Westbourne's Victorian shopping arcade. It contains nineteen seats and is situated in the basement of the Vintage Lounge. It shows mainly classic films from the 1950s, '60s and '70s, and also the occasional sporting event, particularly international rugby union.

## Closed-circuit Television (CCTV)

Bournemouth was the first local council in Great Britain to undergo large-scale installation of CCTV cameras. They were introduced on the seafront before the 1985 Conservative Party Conference, a year after the Brighton IRA bombing at the previous Conservative Party Conference.

The intention was also to deter petty vandalism and crime, but more than two decades later, the system was updated after it failed to detect vandals who set fire to beach huts in the vicinity.

*Above left*: Britain's smallest cinema.

*Above right*: Britain's smallest cinema resides in Westbourne's Victorian shopping arcade.

## Christopher Creek (1820–86)

Christopher Creek was an architect and surveyor who was involved in extending the Royal Bath Hotel. He also conducted the first town survey and as a result rectified the town's lack of proper drainage, water supply and refuse collection.

There is a statue in his honour outside the Bournemouth International Centre which features him irreverently sitting on the toilet. The same statue also features another of Bournemouth's famous sons, Captain Lewis Tregonwell, holding a scroll with Bournemouth's Victoria Cross winners on (*see* Introduction and Wartime and Aeronautical Events).

Christopher Creek achieved the ultimate accolade of having a Bournemouth pub named after him, and he is buried in the Wimborne Road cemetery, which he also designed.

## Disco Heat

Bournemouth's original fire station opened in 1902 and was upgraded in 1930.

In 1995 the Grade II listed building was converted into a Firkin pub called 'The Firefly and Firkin', which became a nightclub called 'Inferno', after the Firkin chain of pubs ceased trading. Its proximity to university halls of residences makes it a popular venue for students.

The building still retains the original stone facade and fireman's pole.

## Disraeli

In 1874, Queen Victoria espoused the virtues of the town and encouraged her Prime Minister, Benjamin Disraeli, who was suffering with gout, to 'try the very salubrious air of Bournemouth'.

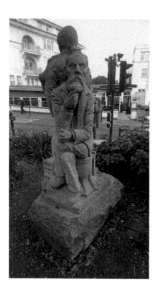 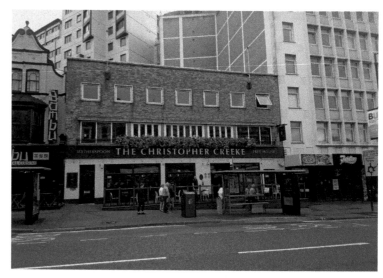

*Above Left*: The statue of Christopher Creek.

*Above right*: The Christopher Creeke Pub (Creeke spelt differently).

The Old Fire Station and Inferno.

The Royal Bath Hotel.

A plaque at the Royal Bath Hotel.

He stayed at the Royal Bath Hotel, from November 1874 until January 1875, and noticed a pronounced improvement in his condition.

During his stay in Bournemouth, Disraeli produced the New Year's Honours list and suggested that Alfred Lord Tennyson should get a baronetcy and Thomas Carlyle the Grand Cross of Bath, to which Queen Victoria readily agreed. However, both men refused the honours when they were offered them.

## First Beach Hut

In 1909, Bournemouth was the first seaside resort in the country to install a static beach hut, as opposed to the bathing machines that were wheeled to the water in the Victorian era.

It was Frederick Percy Delamore (1869–1951), the Chief Assistant Borough Engineer and Surveyor, who came up with the idea.

Other seaside resorts quickly followed suit, but Bournemouth had stolen a march on its rivals.

 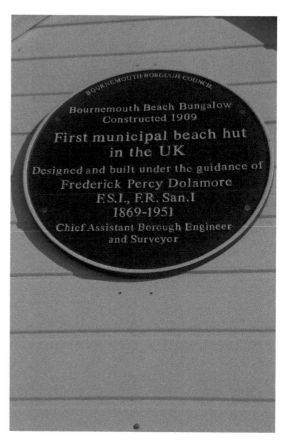

*Above left*: Britain's first municipal beach hut.

*Above right*: A plaque on Britain's first municipal beach hut.

## Fisherman's Cliff Railway (Southbourne Funicular Railway)

Fisherman's Cliff Railway is one of the town's three funicular railways, the others being the West Cliff Funicular Railway and the East Cliff Funicular Railway. The Fisherman's Cliff Railway was opened in 1735 by Bournemouth Corporation, and links the promenade with the clifftop coastal road. Its claim to fame is that it is the world's shortest funicular railway.

## Gladstone

William Ewart Gladstone (1809–98) was the liberal adversary to the conservative Benjamin Disraeli. He was Prime Minister on four separate occasions for a total of twelve years.

He was a frequent visitor to Bournemouth, and is commemorated by a Gladstone Suite in the Royal Bath Hotel, a Gladstone Room in the Langtry Manor Hotel, a Gladstone Road in Boscombe and a Gladstone Close in Christchurch.

In 1898, he made what was to be his final trip to the town. On his way home, he was spotted at Bournemouth Central Station, where a man in the crowd shouted, 'God bless you Sir', to which he replied 'God bless you all, and this place, and the land we love.' These were his last words before he died later that day, having made it home.

The Fishermen's Cliff Funicular Railway, Southbourne.

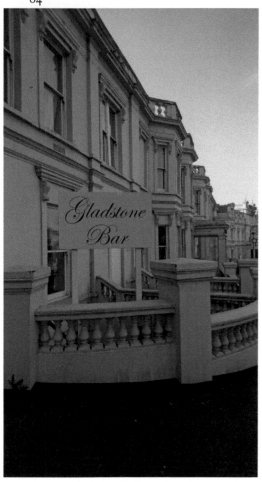

The Gladstone Bar at the Royal Bath Hotel.

## Granville Chambers

Dr Augustus Granville (1783–1872) played a pivotal role in the development of Bournemouth when he wrote a book called *The Spas of England*, in which he predicted that 'Bournemouth would become Britain's premier resort as its waters were free of "dung infiltration"' (*see* Introduction).

Granville was a devout teetotaller, and in 1891, Granville Hotel in Richmond Hill was built as an alcohol-free temperance hotel in his honour. Later in 1930, the building was converted to offices and renamed Granville Chambers.

## Jack the Ripper

The serial killer of London's East End, who was known to have committed at least five gruesome murders during 1888, is connected to Bournemouth via the policeman who investigated the case, Chief Inspector Frederick Abberline (1843–1929). He retired to Bournemouth in 1904, and lived (inappropriately, considering he failed to catch the ripper) in a house called *Estcourt* in Holdenhurst Road.

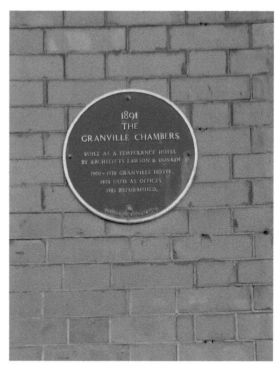

*Above left*: Granville Chambers.

*Above right*: A plaque at
Granville Chambers.

*Right*: The house where Inspector
Abberline, the policeman who
investigated the 'Jack the Ripper'
murders, spent his retirement.

## Joseph's Steps (West Cliff Zig Zag)

The West Cliff Zig Zag was originally known as Joseph's Steps, and began as a series of little steps linking perilous cliff paths at Little Durley Chine. They were named after Joseph Cutler, who was born in 1830 at the Horse and Groom pub in Bargates, Christchurch, which in more recent years, after becoming several different nightclubs, has now become a convenience store and flats.

After leaving school he initially followed his father into the trades of rabbit and oyster catching, before leaving for the temptations of the Australian Gold Fields.

On his return to Bournemouth he worked as a foreman for H. Jenkins builders, before branching out on his own. He struggled initially and had to declare himself bankrupt in 1869, before finally achieving success.

In 1883, he constructed the Zig Zag path at West Cliff, using salvaged timber from the pier, which conveniently led to bathing machines owned by a certain Mr J. Cutler.

He was instrumental in starting Bournemouth's first fire brigade and was a volunteer firefighter himself. He was also active in the initiation of the first Bournemouth Borough Council, where he was described as a little dictator.

## Marconi

Guglielmo Marconi (1874–1937), an Italian from Bologna, came to England in order to develop his wireless communication system, having had his offer to develop it with the Italian Ministry of Posts and Telegraphs rejected.

In 1896, he broadcast the first ever radio signals from the Haven Hotel in Sandbanks, Poole, to the Isle of Wight, using a 120-foot mast. Then in 1897, he established the world's first permanent wireless station on the island at Alum Bay.

The West Cliff Zig Zag, originally known as Joseph's Steps.

In 1898, Marconi set up another transmitting station at the Madiera Hotel, which is now The Court Royal on Bournemouth's West Cliff. However, after a dispute with the hotel management, he moved his equipment to a nearby house called Sandhills, where on 3 June 1898, using a 125-foot mast, he received the world's first commercial radio message from the Isle of Wight.

The success of these early experiments allowed him to transmit the first transatlantic radio message from Angrouse Cliffs just south of Poldhu Cove near Mullion in Cornwall, in which three dots (S in Morse code) were received in Newfoundland on 12 December 1901.

Many aspects of our lives today, including radio, television, satellite links and mobile phones, owe their development to these broadcasts.

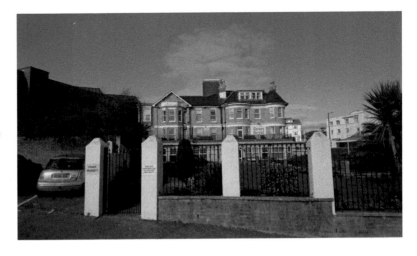

The Court Royal Hotel, which was the Madeira Hotel when Marconi received the world's first commercial radio message from the Isle of Wight on 3 June 1898.

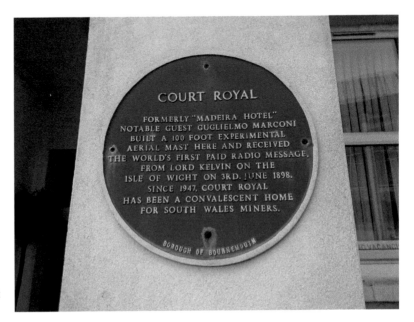

A plaque at the Court Royal Hotel.

## Monte Dore Hotel

The plush Monte Dore Hotel opened in 1885 and practised a treatment called the Monte Dore cure, which was a form of treatment carried out in the French town of Monte Dore in Auvergne. The remedy used water from Auvergne, and involved drinking it, gargling with it and inhaling it. Additional therapies involved Turkish baths and sea baths.

The hotel, which was set a little way back from the sea, was considered to be the most magnificent in the south of England and was Bournemouth's premier spa for the affluent and infirm.

It was commandeered for use as a hospital during the First World War, and then after the war was bought by Bournemouth Corporation to become the Town Hall in 1921.

## Mural

A mural painted by renowned graffiti artist Rick Walker was commissioned by the Consumer Education Initiative in 2016 to celebrate the town's creative and sporting achievements.

Among the different facets of Bournemouth on view are Tommy Elphick, AFC Bournemouth captain at the time; Robert Louis Stevenson's famous characters Dr Jekyll and Mr Hyde; the world champion break dance crew 'Second to None'; and Bournemouth University's computer animation for the Oscar-winning film *Gravity*.

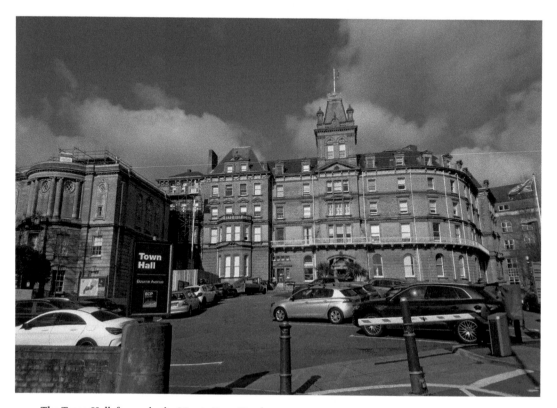

The Town Hall, formerly the Monte Dore Hotel.

A mural painted by renowned graffiti artist Rick Walker depicting different facets of Bournemouth's sporting and creative achievements.

Did You Know?
Naked rambler Stephen Gough from Bournemouth was arrested fifteen times during a ramble from Lands End to John o' Groats in 2003. The fact that he only wore a pair of walking boots and socks may have had something to do with it...

## Oh Those Russians

Vladimir Tchertkoff was a wealthy aristocrat and a favourite at the Tsar's Russian Imperial Court prior to the Russian Revolution of 1917. He was also a reformer, a writer and a friend of the famous writer Leo Tolstoy who wrote *War and Peace*. Like his friend Tolstoy, he gave up his wealth to devote his life to helping the Russian peasantry.

He was also a political agitator, and the Russian establishment gave him the stark choice of living under house arrest, or going into exile; so he came to England with a group of around thirty like-minded Russian intellectuals who were also escaping from Tsarist tyranny.

They established their colony at Tuckton House in Saxonbury Road and also set up a printing works in an old water board pumping station at Iford Lane, Southbourne. Tchertkoff became Tolstoy's literary agent outside of Russia, and the colony printed and distributed his work.

One of the Russian colonists, Alexander Sirnis, had a daughter, Melita Norwood (née Sirnis, 1912–2005), who was born in Bournemouth and went on to betray the country that had given her family sanctuary, by becoming the most important British agent in the KGB'S history, and the longest-serving British Soviet spy.

Tchertkoff's mother, Countess Tchertkoff, also moved to Bournemouth to escape the regime that had executed her husband. She lived in a holiday home called Slavanka in Tuckton.

Tchertkoff stayed in Bournemouth until 1908, when he was authorised to return to Russia. Upon his return, he lived and worked with Tolstoy, until his death in 1910 aged eighty-two. Tchertkoff remained in Russia after Tolstoy's death until 1936, when he also died at the age of eighty-two.

His mother remained in Tuckton, but having donated vast sums of money to help the poor in St Petersburg, was now poor herself, and had to sell Slavanka. However, she was able to remain in residence until the end of her days.

She died in 1922 aged ninety-one, and was buried in Christchurch cemetery.

## Pier Clock

James Fisher Medical Centre in Tolpuddle Gardens, Muscliffe, boasts an impressive rooftop structure; but what few people realise is that this was originally a clock housing that was situated on Bournemouth Pier.

The clock was removed from the pier after it was damaged by a German bomb during the Second World War, and somehow the clock housing found its way to the top of the James Fisher Medical Centre, the four clock faces having been replaced by stained glass.

## Pines

A book that played an important part in the development of Bournemouth was the *Medical Aspects of Bournemouth and Its Surroundings* by Dr Dobell, published in 1882. In the book he extolled the virtues of Bournemouth as a spa town and also wrote 'I consider the heathland character of the site of Bournemouth of utmost importance in its medical aspects and much gratitude is due to early planners for not building houses under the cliffs but on them.' He also wrote that 'the perfume of the pine trees and the infusion

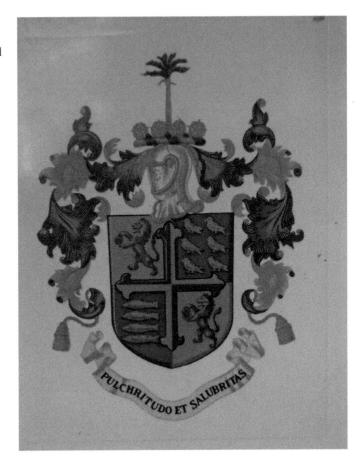

*Above*: The clock on top of the James fisher Medical Centre in Muscliffe was originally situated on Bournemouth Pier.

*Right*: Bournemouth's heraldic crest.

of tar extracted from the trees, is important in treating consumption one of the most common illnesses of Victorian England'.

In fact, the supposed health benefits of the pine tree have been so important for the development of Bournemouth as a town that one is featured on the town's heraldic crest.

The Bournemouth landscape was originally one of gorse-covered heathland, but the landscape was transformed by the systematic planting of conifers, which were predominantly Caledonian or Scots pine.

Tregonwell planted pines in the Central Gardens to provide a sheltered 'pine walk' to the beach, which have mostly been displaced by a variety of trees from all over the world. However, there are still a few pines in existence from Tregonwell's time, the most notable of which towers above the Grade II listed bandstand, and is commonly known as the Bournemouth pine. It is a Maritime pine, which is native to the Mediterranean.

The Bournemouth Pine is believed to be one of the original pines planted in Tregonwell's time.

## Spire of St Peter's Church

St Peter's Church is a Grade I listed building and is classed as a major parish church. It was designed by G. E. Street as the founding church of Bournemouth.

The church is situated within the diocese of Salisbury, and its mother church, Salisbury Cathedral, has the tallest spire in Britain.

Did You Know?
The spire of St Peter's Church is 202 feet tall, which is exactly half of the size of Salisbury Cathedral's spire.

## Stourfield House

Stourfield House in Southbourne was built in 1766, and was considered to be the first building of note in the Borough of Bournemouth, although it is predated by Bourne House (*see* Smugglers).

The house was originally built for a barrister by the name of Edmund Bott, but was acquired by Sir George Tapps upon Bott's death.

Tapps rented it out to its most famous resident, Mary Bowes, Countess of Strathmore and Kinghorne and an ancestor of Her Majesty Queen Elizabeth II. She lived at the house

Stourfield House.

from 1795 until her death in 1800. She was known for her eccentricity and always insisted that her butler set places for her pet dogs at the dinner table.

In 1844 the house was purchased by Admiral William Popham, whose family owned the property until 1893, when it became a school, before becoming the House Sanatorium, and later the Douglas House Hospital.

The building was demolished in 1991 and replaced in 1993 by a new building which retained the original grandiose dual staircases and porch.

## Street Life

There is only one street in Bournemouth town centre, which is Orchard Street, connecting Commercial Road and Terrace Road; even the High Street is actually called Old Christchurch Road.

The reason for this is that the town's early residents thought that to have streets was far too common, so instead opted for roads.

The name of the street referred to an orchard that was in the vicinity, but has long since disappeared.

Did You Know?
Bournemouth was voted the winner of the 'Best UK Seaside Town' in the prestigious 2019 British Travel Awards.

# Bibliography

Ashley, H. *Bournemouth* (1988)

*Did You Know? Bournemouth A Miscellany* (Francis Frith, 2006)

Hilliam, D., *The Little Book of Dorset* (The History Press, 2010)

Jackson, A., *Poole Pubs* (Amberley Publishing, 2019)

Jackson, A., *Historic England: Dorset* (Amberley Publishing, 2020)

Needham, J., *Bournemouth Past and Present* (The History Press, 2010)

Norman, A., *Founders and Famous Visitors* (The History Press, 2010)

Perrin, L., A., *Century of Bournemouth* (Sutton Publishers, 2002)

Richards, A., *Slow Travel Dorset* ( Bradt, 2015)

*Ward Lock and Co's Bournemouth* (Ward Lock and Co.)

## Websites

www.bbc.co.uk

www.bournemouthairport.com

www.bournemouth.co.uk

www.bournemouthecho.co.uk

www.bournemouth.gov.uk

www.dorsetancestry.webeden.co.uk

www.dorsetlife.co.uk

www.dorsetmagazine.co.uk

www.eastcliffcottage.com

www.flickr.com

www.footballhistory.org

www.iwm.org.uk

www.jdweatherspoon.com

www.joneggingtrust.org.uk

www.mags4dorset.co.uk

www.moonfleetofkinson.co.uk

www.news.bbc.co.uk

www.premierskillsenglishbritishcouncil.org

www.resortdorset.com

www.robert-louisstevenson.org

www.shelleytheatre.co.uk

www.visit-dorset.com

## Information Boards
Alum Chine
Bournemouth Gardens
Charles Bennett, Shapwick
East Cliff Hotel
Kinson House
Skerryvore
Smugglers Cove golf course
St Peter's Churchyard
Thomas Hardy, Bournemouth Gardens
West Hants Tennis Club

## Sporting Programmes
Bournemouth v Scunthorpe 1 April 2013
Hampshire v Northants 16 August 1992
Wimborne Town v Bournemouth 8 August 2012